IMAGES
of America

FIR ISLAND AND CONWAY

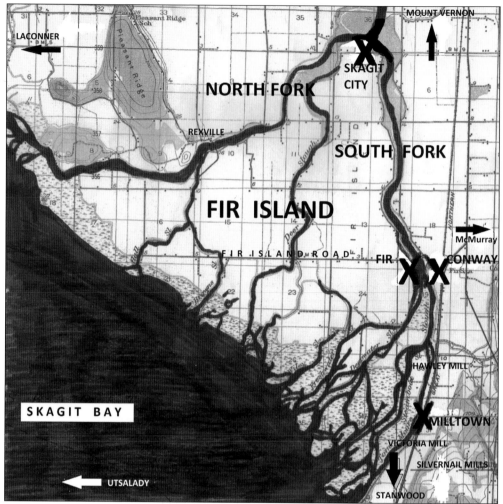

Indians inhabited the area around the mouth of the Skagit River, shown in this map of the lower Skagit region, long before the arrival of early pioneers. Some early navigators settled near the riverbanks, and in the 1870s, others began even more exploration. Fish were abundant. Logging and land-clearing opened up prime fertile soil for farming, and homesteads were soon established. (Patricia Hanstad Pleas.)

ON THE COVER: The Fir Lutheran Synode Church was built in 1896. The little church was replaced with a larger structure in 1914 due to a growing population; in that same year, a bridge was built connecting Fir to Conway. The church was finished and dedicated in 1916. The congregations of Fir and Conway merged in 1917, and the Fir-Conway Lutheran Church has served the area ever since. (Howard "Bud" Tronsdal.)

IMAGES
of America

FIR ISLAND
AND CONWAY

Patricia Hanstad Pleas, Janet K. Utgard,
and Andrea Millward Xaver

ARCADIA
PUBLISHING

Published by Arcadia Publishing
Charleston, South Carolina

Printed in the United States of America

Library of Congress Control Number: 2016947567

For all general information, please contact Arcadia Publishing:
Telephone 843-853-2070
Fax 843-853-0044
E-mail sales@arcadiapublishing.com
For customer service and orders:
Toll-Free 1-888-313-2665

Visit us on the Internet at www.arcadiapublishing.com

*In honor of our parents, who taught us the value of family history,
and to the memory of early inhabitants and pioneers.*

CONTENTS

Acknowledgments 6

Introduction 7

1. Early Inhabitants 9

2. Skagit City 13

3. Conway 17

4. Fir, "Mann's Landing" 63

5. Milltown 99

Bibliography 126

Index 127

ACKNOWLEDGMENTS

Carrie Hanseth Brodland's hand-drawn sketches of Fir and typed historical information were found in Rose Hanstad Carlson's collection of photographs, inspiring the writing of this book. Bob Hanseth and Arlyne Brodland Wollan confirmed the information with their three-ring binders of "Carrie's Book."

When word got out that this book was being written, more material became known to us. Historical notes written by Mamie Johnson Moen were donated by Howard "Bud" Tronsdal, and notes on the Peter Egtvet and Ole N. Lee families were graciously donated by Solveig M. Lee. All of these provided us with valuable tools to unlock a treasure of history.

Wonderful photographs and history were shared by the descendants of pioneer families—we cannot thank them enough. With many identical photographs from contributors, we did our best to provide an assortment of images. Names given to us for persons in photographs may have incorrect spellings, and for that we apologize.

We especially want to thank, in random order, the generosity of the following for their support, knowledge, and the time taken to share their wonderful collections and information; Solveig M. Lee, Anna Lee Ankrum, Howard "Bud" Tronsdal, Dallas R. Wylie, Vicki Carlson Archer (for sharing Rose Hanstad Carlson's collection), Margaret Utgard, Michael Bonser, Janet K. Utgard, Patricia Hanstad Pleas, Andrea Millward Xaver, L. Richard Larson, the Sons of Norway Abel Lodge 29, Maxine Axelson Shroyer, Stuart Lange, Bob Hanseth, Dorothy Noste Johnson, Curt Tronsdal, Darlene Krangnes, Arlyne Brodland Wollan, Larry C. Wollan, Georgia Silvernail Fischer, Susan Hughes-Hayton, Diana Tingley Weppler, Ann Lamb, Robert Sund, Maynard Axelson, May Wolden Larson, Warner A. Exelby, the Stanwood Area Historical Society, and the Skagit County Historical Museum. We would also like to express our gratitude to those at the Conway School District and Fir-Conway Lutheran Church for their support in this project.

As descendants of Skagit County pioneers, we enthusiastically put this book together. We hope others will be encouraged to ask questions, find names, and save photographs and documents for future generations. This book has been a journey of compassion and respect for the Indians and settlers who left us this legacy.

INTRODUCTION

Indian tribes inhabited the area around Conway and Fir Island long before any white man navigated the Skagit River. One tribe known to inhabit Fir Island was the Kik-i-allus (or Kikiallus). The Snohomish and Stillaguamish tribes were also known to inhabit this area.

William H. Sartwell is recorded as being the first non-native settler in the area, building what has been described as the first permanent structure, a cabin, along the riverbank in 1863. Magnus Anderson bought Sartwell's cabin in 1869.

Barker's Trading Post, located where the north fork and the south fork of the Skagit River diverged, opened in 1869 and became an important transportation center. The nearby area became known as Skagit City.

In the 1870s, Indians were found to be friendly by those navigating the north and south forks of the river. Settlers sought a new life, making their homes here, and many early men arriving to the area married Indian women.

Once settled, early pioneers would travel to Utsalady to trade butter, eggs, ham, bacon, lard, potatoes, and other goods to acquire money or other necessities. This required getting into a boat and rowing six miles to Utsalady. The round trip usually took all day.

Another pioneer was Samuel Simpson Tingley, a farmer and shipbuilder who came to the mouth of the Skagit in 1867 and became one of the earliest settlers. He was famous for helping to build almost all the ferries that plied the river.

Alfred Polson grew up on his parent's homestead, which was established in 1871 near Brown's Slough on Fir Island. Polson married Cora Hayton, the daughter of another pioneer family. Polson was said to be a staunch supporter of quality education.

Ole N. Lee and Anna Egtvedt Lee arrived at Skagit City in 1876, making their home on the east side of the south fork. The Lee family held the first church services in the area at their home.

Peter Egtvet was drawn to Puget Sound around 1876 and secured a claim near the mouth of the Skagit River. Floods were a constant danger, so in 1883, Egtvet sold his land and bought 240 acres south of Mount Vernon near the homestead of his sister Anna and brother-in-law Ole N. Lee.

Thomas Hayton and Sarah Saunders Hayton arrived at Fir in 1876 and welcomed a son, James B. Hayton, to their already growing family in 1877. James would go on to marry Maud Good.

Andrew N. Crogstad was an ironworker in shipbuilding. He came to the area in 1877, leasing Captain Loveland's farm, located about one-and-a-half miles southwest of Fir, for three years. Crogstad later purchased the Jacob Hayton place.

Bengt Johnson made his way into the area history books for the dikes he built.

Numerous other pioneers and settlers deserve recognition, but there are not enough pages to mention them all. Many of those who settled in the Fir, Conway, Skagit City, and Milltown areas during the late 19th century still have descendants living in the area today.

Mamie Johnson Moen, in her writings, noted that Caroline Lisk Ball, an Indian woman, had been heard to say, "years ago, when I was young, there were no white people around here, only Indians and Norwegians." Moen stated that that may have been partly true in the 1890s, when Norwegians began coming to the area direct from Norway.

Conway was founded by Thomas P. Jones and Charles Villeneuve in 1873. Villeneuve was from Ottawa in Ontario, Canada. Jones emigrated from Conway, Wales. In July 1874, Jones bought 120 acres of land, which included the future townsite of Conway, Washington.

Charles H. Mann, a Civil War veteran, established a claim on the west bank of the south fork in 1874. He built a trading store at what became known as Mann's Landing, one of the first river ports in Skagit County.

Skagit City continued to thrive through the 1880s, when Mount Vernon, which was upstream, began to prosper.

Around 1882, Magnus Anderson, also a pioneer to the area, had replaced the older hotel at Mann's Landing with a new two-story building. At first, Charles and Ann Villeneuve took charge of the building.

Villeneuve then purchased land on the east side of the river and began operating a ferry across the Skagit. The first store in Conway was built by Villeneuve, who also arranged for housing boarders.

On April 10, 1885, a fire wiped out every business building at Mann's Landing. The loss totaled $17,000, with few covered by insurance. The rebuilding of the town started immediately, and businesses were reestablished.

It was not until 1891, when the Great Northern Railway came through, that Thomas P. Jones and his wife, Josie, platted the town of Conway.

In 1892, a big flood destroyed almost everything at Conway except Villeneuve's store. After the flood, Villeneuve leased the Conway store to William Bonser. Within a year, Bonser gave it back to Villeneuve. Magnus Anderson later bought the store from Villeneuve, then sold it to John Melkild.

William Bonser's son, George William Bonser, became a clerk at the Milltown store. Milltown had a boardinghouse, a store, three saloons, a community hall/dance hall, and a pool hall, along with several shingle and lumber mills in the area.

In 1893, eight years after the first fire at Mann's Landing, another devastating fire caused $25,000 in damage to Mann's Landing buildings, with business owners having only $11,000 of insurance.

Charles H. Mann married Rebecca D. Huntington on June 4, 1889, at the Arlington Hotel in Seattle. On December 15, 1899, at the age of 56, he died at Fir and was buried at the Mount Vernon Cemetery.

Ole J. Borseth owned a store on the north end of Mann's Landing. Boats regularly stopped at the landing to sell, trade, or deliver goods.

Although Skagit City played a big part in the settlement of Skagit County, by 1906, it is said there was only one building remaining in the town.

A bridge from Conway to Fir Island was completed on July 4, 1914, and a month later, on August 15, 1914, people came from all over to celebrate the dedication. That same year, a new church was built at Fir to replace the smaller Fir Lutheran Synode Church.

In June 1915, the people of Conway and the nearby vicinity established a bank and organized the State Bank of Conway with capital stock of $10,000. On June 24 of that same year, the bank was converted to the First National Bank of Conway with capital stock having increased to $25,000.

The dedication of the new Fir Lutheran Church was held in 1916, although services had been held during construction and through the building's completion. In 1917, Fir Lutheran Synode Church and Conway Norwegian Evangelical Lutheran Church merged, becoming the Fir-Conway Lutheran Church.

When the stock market crash of 1929 was felt by so many, farming communities managed better than some; however, the bank at Conway had to close its doors five years later.

Flooding has always been a threat to the area. Dikes have broken and been rebuilt several times over the years. The dike district has done its job to protect the people, but the wrath of Mother Nature is always a possibility and a concern.

One

EARLY INHABITANTS

Native Americans made their homes and camped in the area long before Washington Territory was established and long before early pioneers arrived. As the white men navigated the rivers in search of gold and land, those who ventured up the mouths of the north and south forks of the Skagit River found most of the Indians they encountered to be friendly. A slough off the south fork of the river on Fir Island was named the Kickialli Slough, and the Kik-i-allus tribe resided in the nearby area. The Snohomish and Stillaguamish tribes also inhabited areas around Conway, Milltown, and Fir Island.

Many white men settled in the area and married Indian women. Some of those men—according to the 1870 census of the Skagit Precinct, Whatcom County, Washington Territory—included John Wilber, J.V. Abbott, and William Butler, all from Maine; Joseph Lisk from New York; Joseph Wilson from Virginia; William H. Sartwell and John Wilson, both from Pennsylvania; William Brown from Sweden; Joseph Maddox from Michigan; and Edward McAlpine from Canada.

As more white men began to arrive and were joined by their wives and families, they found that there was much to be learned from the Indians. The Indian women taught white women many skills to assist them with their survival in this primitive area.

The Indians mainly traveled on foot or by canoe; early travel by white settlers relied on similar methods.

Today, many descendants of those Indians and first settlers live throughout the Skagit Valley.

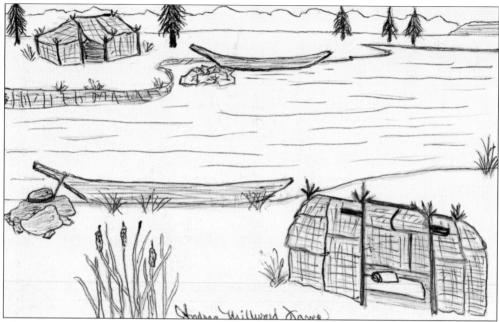

The Kik-i-allus, Snohomish, and Stillaguamish, all local Indian tribes, made tents using matting. This was woven from long grasses found near the rivers and bays. The grass was partly dried before it was woven. These tents provided the natives with summer housing as they traveled along the Skagit River and its tributaries in search of food. Cedar was critical for building both canoes and permanent housing. Many children of local tribes attended school at Tulalip. In the 1870s, the federal government authorized a school for Indian children in the Northwest. Many of those with Indian bloodlines attended the United States Indian Training School at Chemawa, Oregon, where they had the opportunity to earn a vocational degree. (Above, Andrea Millward Xaver; below, Larry C. Wollan.)

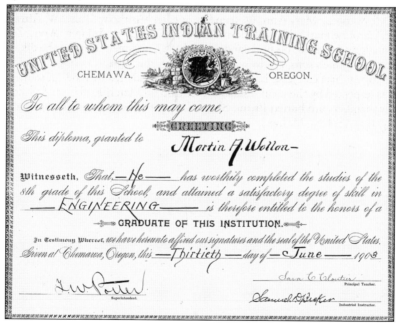

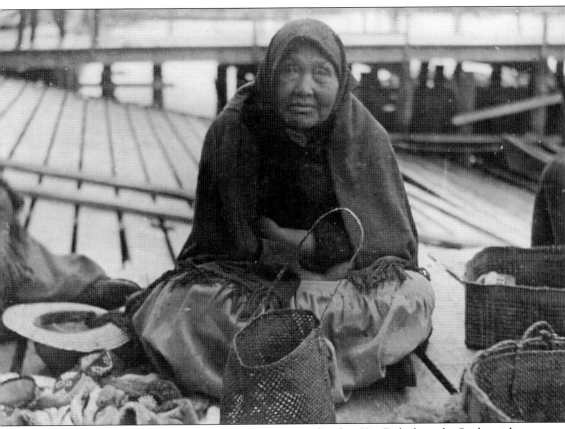

Swalluck Tahles, of the Kik-i-allus tribe, married a man, Shwahta-Kay-Dub, from the Snohomish tribe. Their daughter, I-Flugh, born around 1851, later became known as Caroline Buckskine. She married a white man, Joseph Harison Lisk. Census reports show they had seven children: Charles, Joseph De, Bell, Maria C., Mary Ann, William Harison, and Anthony "Tony" W. After Lisk's death around 1878, Caroline married Jesse Ball in 1881. They had three children: Andy, Zola Matilda, and Kate. Smallpox broke out on Fir Island around 1887, and men working the dikes were quite fearful. One of Caroline's sons, Andy, was stricken with smallpox, resulting in blindness in one eye and scarring on his face. Jesse Ball was also stricken and died in 1889. Caroline lived many years and was respected by the local residents. She died on March 1, 1938, and although several of her family members are buried in the Skagit City Cemetery, she was buried at the Mount Vernon Cemetery. (Solveig M. Lee.)

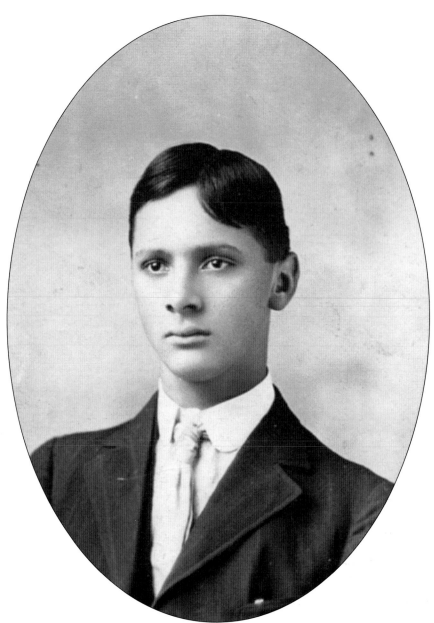

Joseph Wollan was born in 1879 to Louis A. Wollan, a white man, and Lydia Sweet Wollan, a woman of Indian descent. His brothers Oliver "Ollie," Martin A., and Nels F. were born after him. Joseph Wollan attended the United States Indian Training School at Chemawa, Oregon, in the Salem area, as did his brother Martin. Ollie had his schooling at Tulalip and was well known at Fir and Conway as a hotelkeeper, fisherman, and businessman. Ollie had a liquor license at Fir and transferred it to Col. Charles F. Treat in 1909. While living in Conway, Ollie owned the Conway Hotel and, later, the Duck Inn Tavern east of the railroad tracks. Martin graduated from the United States Indian Training School in 1903 with a degree in engineering and began working in the logging industry. Joseph became a mechanic working with the railroad. Nels died in 1910 at age 19. The Wollan family roots run deep in Fir, Conway, and Snohomish and Skagit Counties. (Larry C. Wollan.)

Two

SKAGIT CITY

The first white settlement in this area arose when a man named Campbell established a store in the area of the Skagit River forks. This was followed by Barker's Trading Post, established by John Barker in 1869, which became an important river transportation center. A portion of a large logjam blocking upstream travel was removed between 1874 and 1876.

The townsite and Barker's Trading Post were originally farther upriver from the final location near where the north and south forks of the Skagit River diverge, but heavy floods washed away the old site.

In 1876, the Skagit City townsite was platted by Edward McAlpine, one of the area's earliest pioneers. By 1879, the river town of Skagit City had hotels, stores, saloons, a school, a church, and other public buildings.

The Skagit City School was established early, but the flood of 1887 led to a new school being built on the east side of the river in 1888.

When Mount Vernon began to prosper in the 1880s, the Skagit City townsite slowly began to disappear.

After flooding in 1901, a new Skagit City School was erected, and in 1902, it was moved to a half-acre donated by Knud Lange on his farm south of the old townsite. Students attended this school until it consolidated with Conway School District in 1939.

The Skagit City School building still stands today on Moore Road, and recently received a new foundation amid extensive preservation efforts.

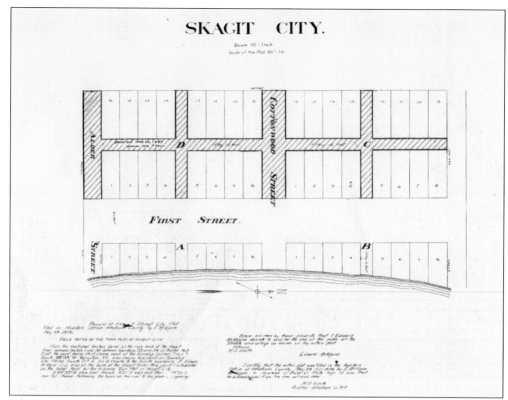

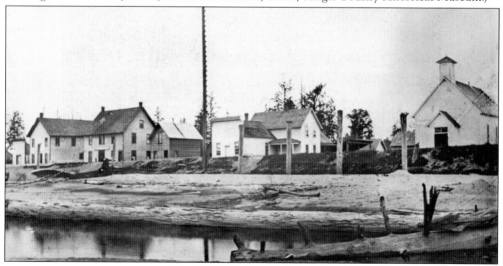

Edward McAlpine filed a plat (above) for the town of Skagit City with the auditor of Whatcom County on May 8, 1876; Skagit County was not established until 1883. Skagit City is pictured below in the 1880s as a fully established town. After a flood in the early 1900s, almost everything washed away. Settlers were used to high water and flooding, but after many years, better diking became necessary. One man known to build sturdy dikes in the area was Bengt Johnson, who made his way into history books for the dikes he built in a short time. However, even the best dikes fell victim to massive flooding from the Skagit River, and today, there is no remaining evidence of the original townsite. (Above, authors' collection; below, Skagit County Historical Museum.)

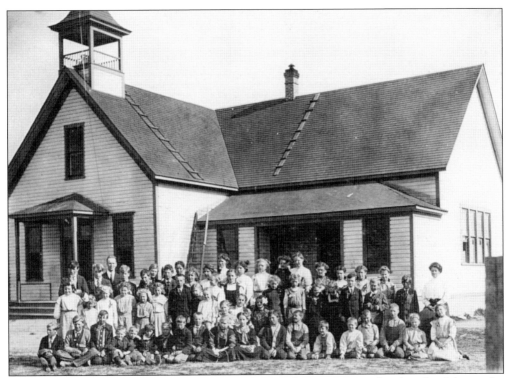

Skagit City School is pictured above in 1907. Below, students are pictured at the school during the 1938–1939 school year; this was the last year students attended the school before its consolidation with Conway. In 1937–1938, Conway School District No. 24 consolidated with the schools of Fir, Milltown, Cedardale, McMurray, and Meadow, but Skagit City held out for one more year. In 1939, Skagit City School consolidated with what became School District No. 317. Pictured below are, from left to right, (first row) Janet Clark, Anita Iverson, Jean Moa, Helen Edler, Marie Wolden, Joyce Hansen, Marilyn Heglin, May Wolden, and teacher Mrs. Carlson; (second row) Arthur Wolden, Donald Hansen, Harlen Hansen, Virginia Mason, Loraine Hein, Leland Moa, Owen Edler, and Leo Wolden. (Above, Skagit County Historical Museum; below, May Wolden Larson.)

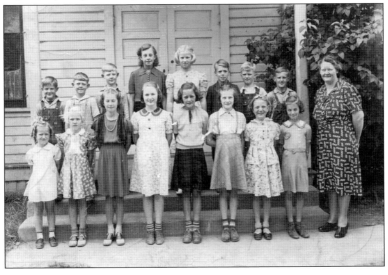

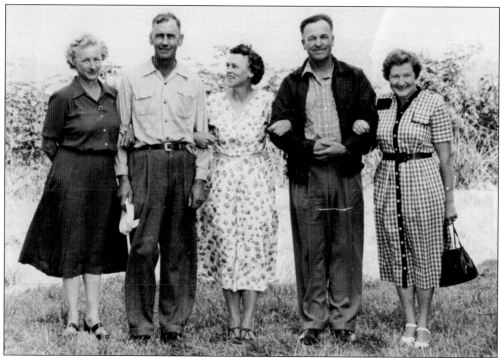

Former Skagit City School students attended a reunion on July 9, 1954. Pictured above enjoying the gathering are, from left to right, Josie Moen Hanson, Art Nelson, Elde Larson Hastie, Clifford Lange, and Bertha Edler. Below are, from left to right, (first row) Clifford Lange, Helen Edler Smith, Hilda Elder, Art Moe, Olga Lee Larson, Mary Melode Whitham, Virginia Mason, Albert Berglund, and Perry Edler; (second row) Carolyn Polstra, unidentified, ? Burklund, Ruby Larson, Josie Moen Hanson, Bertha Edler, Elde Larson Hastie, Francis McCormick, Art Johnson, and Melvin Hanson; (third row) Nellie Lange Lee, Bertha Toft Lee, Ruth Martinson Lindberg, unidentified, ? Keith, Olga Larson, Nora Johnson, Elinor Larson, unidentified, ? Larson, Owen Edler, Beatrice Johnson, ? McCormick, Noble Lee, ? Burklund, ? Nelson, Hattie Lee Mason, Agnes Bylund, Olaf Edler, Johnny Polstra, Pearl Enquist Parks, Amanda Fjelstid, and Andew Edler. (Both, Stuart Lange.)

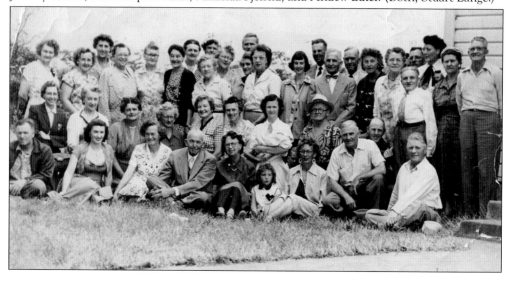

Three

CONWAY

Conway, located on the southeastern bank of the Skagit River opposite of Fir, was founded by Thomas P. Jones and Charles Villeneuve in 1873.

In 1891, the Great Northern Railway came through, with the railroad owners choosing Conway as the location for their Fir station. Jones and his wife, Josie, platted the town, and Villeneuve bought four lots near the station, building a general store there. In 1891, Conway and Fir were both growing at about the same pace.

A big flood around 1892 destroyed almost everything in town except for Villeneuve's store. The people of Conway swiftly began to rebuild, and businesses continued to grow.

A hotel, store, meat market, pool hall, blacksmith shop, and church made up the beginnings of the town. In 1900, the population of Conway-Fir was reported as 699.

Finstad and Utgard Creamery opened in 1904 with John S. Finstad in charge and Peter K. Utgard as his business partner. The creamery was one of the most successful manufacturing plants in the Puget Sound region. Around the 1920s, seven men worked in the plant—Peter G. Utgard (foreman), Dewey Utgard, Coit Utgard, Robert Hanstad, A.M. Brevick, Sivert Ranes, and Walt Wollan.

A bridge joining Conway and Fir was built in 1914, helping the growth of the town.

In June 1915, the people of Conway and the nearby vicinity established the State Bank of Conway, which converted later that year to the First National Bank of Conway. Five years after the stock market crash of 1929, the bank was forced to close its doors.

As members of a farming community, the people of Conway have remained strong and resilient.

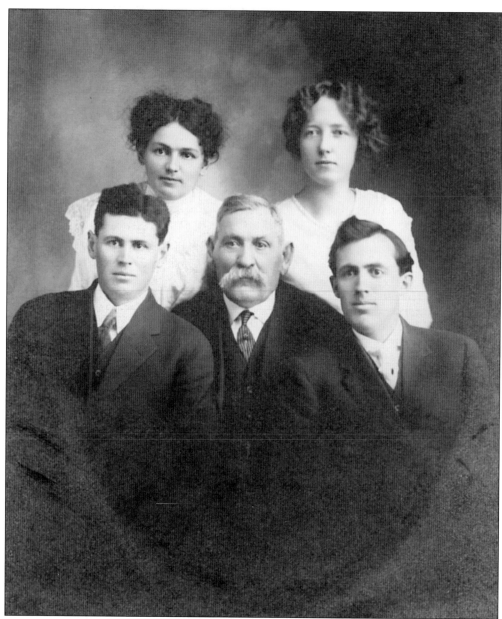

Ole N. Lee (1831–1924) arrived in 1876 with a party of other men in a combination sail- and rowboat named the *Union Jack* in search of a place for a future home. Lee's wife, Anna Egtvedt Lee, would join him later. The party turned their course to the south fork of the Skagit River and proceeded upriver toward Skagit City, the head of navigation, where a post was run by Daniel E. Gage. Lee found the perfect place on the east side of the river before Skagit City. The men rowed to land, unloaded their goods, and began clearing the land. Trees and brush stood so close to the riverbank that it took Lee many years before he could clear a path to his land farthest from the river. The river was their main form of transportation. Lee (first row, center) is pictured here with his daughter Nellie Ida Prezella Lee (second row, left) and Petra Mathilde Brenden (second row, right), who would marry Lee's son, Oscar (first row, right); at left in the first row is Ole's son Peter. (Solveig M. Lee.)

Anna Egtvedt Lee (right) left Seattle in 1876 aboard the steamer *Fanny Lake* to look for her husband, Ole N. Lee. She found him, with his work party, and was let off the steamer on the east side of the south fork of the Skagit River. She found five trees had been cut down to make a floor space, and other wood was only partially assembled. One week after her arrival, she gave birth to their first child, a daughter, Nellie Ida Prezella Lee, on November 28. Their sons, Peter and Oscar, were born later. Anna Egtvedt Lee and Ole N. Lee are pictured below in front of their home, which was built by Peder Gjerde around 1900. Lee's daughter Nellie designed it. Lee and his three children developed the property north of Conway and bought 20 head of Holstein foundation stock. The cattle were brought in by barge, unloaded, and driven down the dike to the farm across the road. (Both, Solveig M. Lee.)

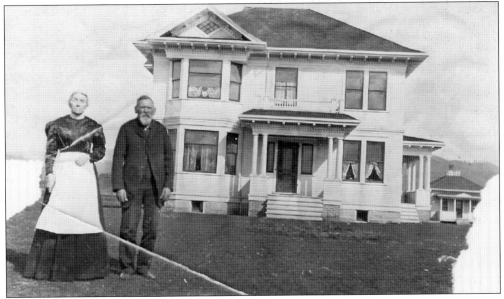

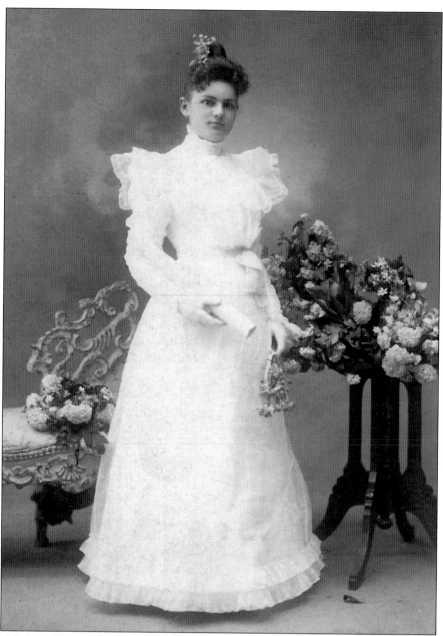

Nellie Ida Prezella Lee, the daughter of Ole N. and Anna Egtvedt Lee, was born on November 28, 1876, and had the distinction of reportedly being the first child of Norwegian parentage to be born on the south fork of the Skagit River. At the time of her birth, the area was quite primitive. Nellie became very active in church and the Ladies' Aid Society. She graduated from Pacific Lutheran University in 1899 as one of only three females graduating from the college that year. She was an active member of the Scandinavian-American Republican Club and was on the board of directors of Mount Vernon Union High School. Along with her brothers, Peter and Oscar, this well-educated woman also managed to farm, raising prize-winning registered Holstein breeding stock. Nellie was very involved with her community and was instrumental in establishing telephone service to the area. (Solveig M. Lee.)

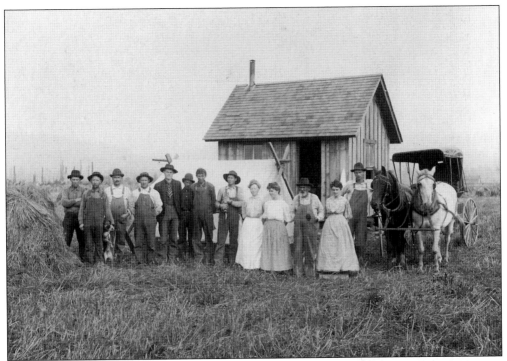

Ole N. Lee is pictured here in front of the doorway with his son Peter (holding a cat) and daughter Nellie (to the right of Ole). The others in the photograph are unidentified. The Lee family became prominent farmers in the area. Known as the Lee Brothers, the family joined the Holstein-Friesian Association of America. The prefix of their registered Holsteins was "Skagit." (Solveig M. Lee.)

John O. Mauseth and Annie Quande were married on November 11, 1908. Annie was the daughter of Ole Peterson Quande and Marie Sivertsdatter Krangnes. She and John had nine children: Andrew, Henry, Gladys, Oliver, Jeanette M., Elroy, Nadine, Joyce, and Barbara. Andrew died when he was an infant in 1909. (Robert Sund.)

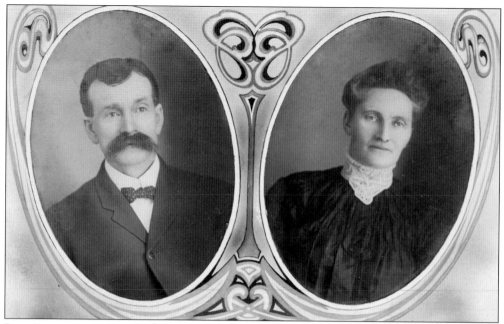

Peter Egtvet came to the Skagit River valley, secured a claim at the mouth of the river, and worked to clear, dike, and improve his farm. The work was hard in those days when freshets were always a concern; often, the labor of months—if not years—was swept away in a single night. In 1883, Egtvet sold the farm and bought a tract of land from the Kelly family five miles south of Mount Vernon and a short distance from the Ole N. Lee family. Egtvet (above left) and Anna Erickson (above right) married on March 15, 1885. The Krangnes family would later become owners of the Egtvet home and property (below). (Both, Solveig M. Lee.)

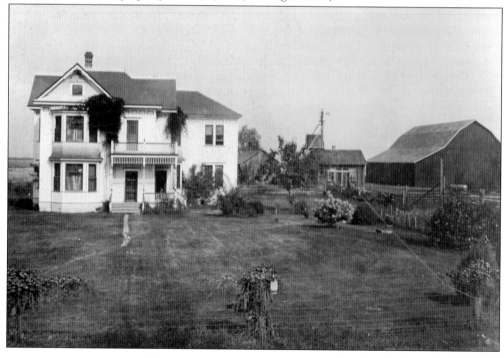

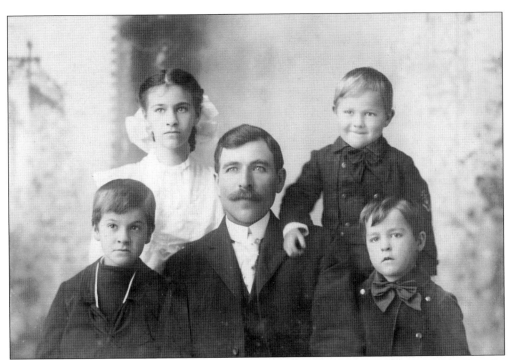

Knud Lange (center) is pictured around 1908 with his children, from left to right, Alfred, Nellie, Leo, and Clifford. Knud's wife, Gurianna "Gertie" Fryseth, died of tuberculosis around 1906. Knud Lange (pronounced "Longe" in the early years) generously donated the land for the Skagit City School. His brothers were Peter and Louis. (Stuart Lange.)

Erland Wold and Lizzie Skrondal were married on June 20, 1909. Lizzie worked in homes around Conway prior to marrying Wold, who was a farmer near Milltown. They had three children, and, sadly, Lizzie died in childbirth in 1918, leaving her husband to raise their children. Lizzie, the only girl in her family, had four brothers; Erland was an only child. (Solveig M. Lee.)

Ole C. Noste was born in Norway in 1892. He became a painting contractor and had a paint shop in Conway. Noste was postmaster of Conway from 1932 to 1962. Postmasters in Conway were reportedly Republicans until Franklin D. Roosevelt became president; at that time, Noste was the only Democrat in the farming community, so he got the job. (Dorothy Noste Johnson.)

Clara Dorthe Borseth, the daughter of Ole J. and Dordi Borseth, was born in 1901 at the family home across the road from the Fir Lutheran Synode Church. She said she was afraid of Indians after hearing their powwows on the riverbank at night. However, her good friend was Leona Lisk Weaver Mann, a descendant of the Indian woman I-Flugh Caroline Buckskine Lisk Ball. (Dorothy Noste Johnson.)

On December 7, 1908, William "Bill" Sund Sr. married Jennie Mauseth. Lutheran pastor H. Ingebritson performed the ceremony. Coit G. Utgard and Minnie Olson were witnesses and later married one another. Sund and his wife had four children: Alfred, Helen Jeanette (who died as an infant), William "Bill" Sund Jr., and Lorraine. (Solveig M. Lee.)

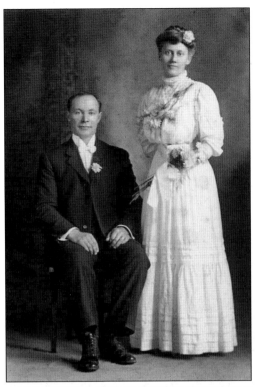

Bill Sund Sr., with the help of Mr. Wilhonen, built this house prior to his marriage to Jennie Mauseth. In this photograph, Sund is sitting on the porch while Jennie holds their son Alfred atop the fence post; Alfred was born in 1909. The house was built around 1908 and was used by the telephone company at one time. It was moved around 1915 when it was replaced by the First National Bank of Conway. (Robert Sund.)

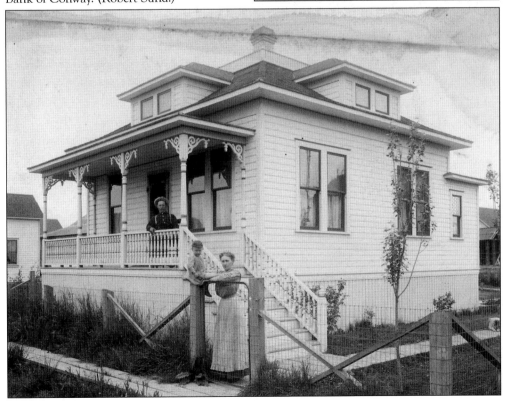

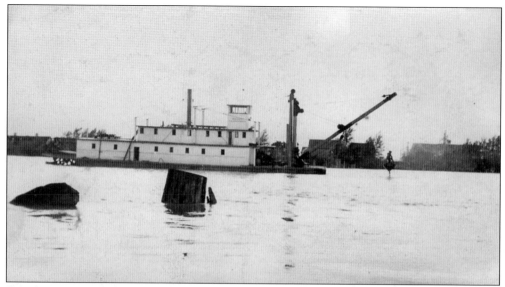

Snag boats were used to clear debris from the Skagit River. Here, the snag boat *Skagit*, a stern-wheeler, is busy at work on the south fork of the river. This boat was operated at one time by Capt. Frederick A. Siegel and made regular stops at Fir and Skagit City. (Solveig M. Lee.)

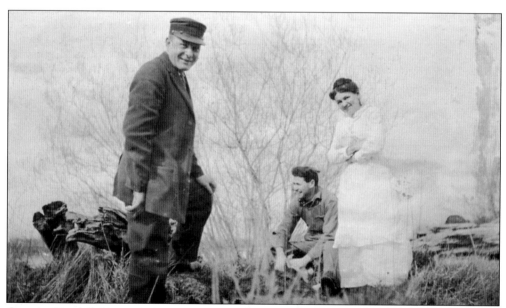

Captain Siegel (left), a snag boat operator, is shown in this c. 1900 photograph with Peter Lee (center) and his sister Nellie I.P. Lee. Snag boats often traveled up and down the river clearing logjams and debris that hindered navigation. (Solveig M. Lee.)

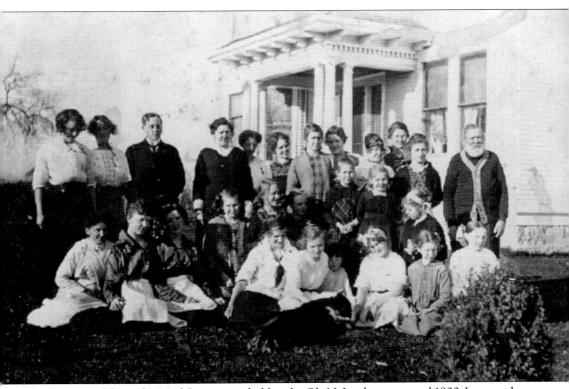

This meeting of the Ladies' Aid Society was held at the Ole N. Lee home around 1900. Lee stands at far right and his daughter Nellie sits on the grass at front center. Some children would meet with the Ladies' Aid Society for religious instruction. Locals traveled by rowboat or wagon or on foot; however, walking was the most common method of travel. Very few people had wagons, and the roads were narrow, rough, and muddy; some were only trails through the woods. The Skagit Norsk Evangelisk Luthersk Kvindeforening (women's society) started on August 18, 1894, under the leadership of Rev. L.C. Foss. Charter members listed at that meeting or shortly afterward included Mrs. Sivert Sande, Mrs. Lars Sande, Mrs. John Lee, Mrs. Ole Lonke, Mrs. John Mauseth, Mrs. Even Hanstad, Mrs. O.P. Quande, Mrs. John Locken, Mrs. John Holt, Mrs. Knute Opdal, Bertha Johnson, Anna Lee, Mrs. Lars Danielson, Mrs. Nels Danielson, Mrs. Christ Olson, Mrs. Lars Engen, and Mrs. George Nelson. (Solveig M. Lee.)

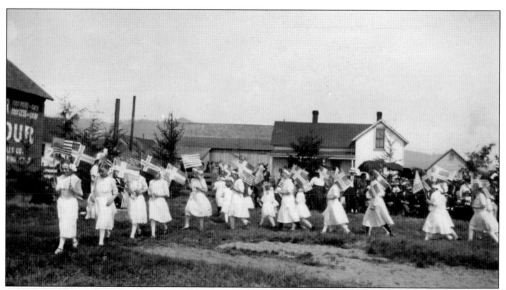

Conway's Syttende Mai ("May 17") festival is being celebrated in this c. 1900 photograph. Norway adopted its constitution on May 16, 1814, and signed it on May 17, 1814. This ended almost 100 years of a coalition with Sweden, preceded by nearly 400 years of Danish rule. The first Syttende Mai celebration in Norway was held in 1836, and the first children's parade was held there in 1870. (Solveig M. Lee.)

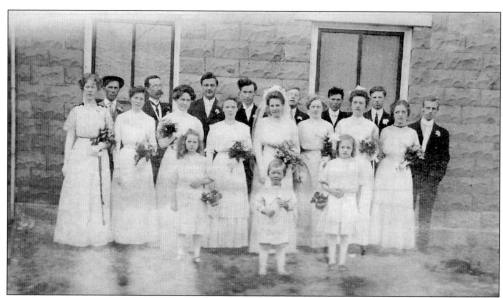

Lewis G. Nyhus was a pioneer educator and community leader. Born in South Dakota, Nyhus came to Conway to teach "Norwegian School." Nyhus (fourth from left in the third row) is pictured at his wedding to Mary Skjervem on June 1, 1911. He went on to serve as the principal of Conway School from 1918 to 1952, when he retired. Nyhus died in 1963. (Solveig M. Lee.)

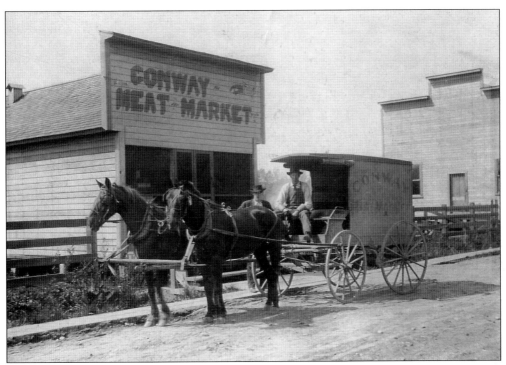

In this c. 1900 photograph, a team of horses and an unidentified driver pause for a photograph in front of the Conway Meat Market as they prepare to make deliveries. The building at far right was at one time a roller rink and was later home to the Conway Auto Company until about 1950. The Sund Building replaced the meat market prior to that. (Robert Sund.)

In this picture looking south, the Bill Sund Sr. home, which was built around 1908, sits in the location that would later house the bank. This house was built prior to Sund's marriage to Jennie Mauseth. Two unidentified men appear to be opening the Conway Meat Market for the day. The other buildings are unidentified. (Curt Tronsdal.)

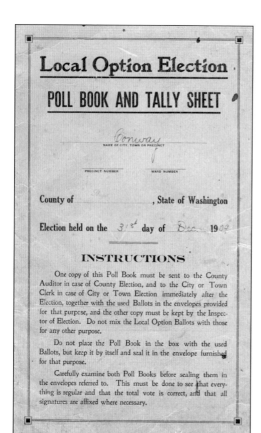

This local option election poll book and tally sheet, dated December 3, 1909, lists 151 voters. Election officials were Lars Engen (inspector of election), John L. Melkild (judge of election), and John S. Finstad (judge of election). Roy E. Stone and John S. Finstad were clerks of election, with Stone signing off that he did the work on the book. (Curt Tronsdal.)

The flood of 1909 is captured in this scene as high water surrounds the Conway Bar and the Finstad and Utgard Creamery. In this photograph, looking southwest, the Conway Norwegian Evangelical Lutheran Church steeple is visible at far right in the background. It is possible the photographer was standing on the Great Northern railroad tracks. (Robert Sund.)

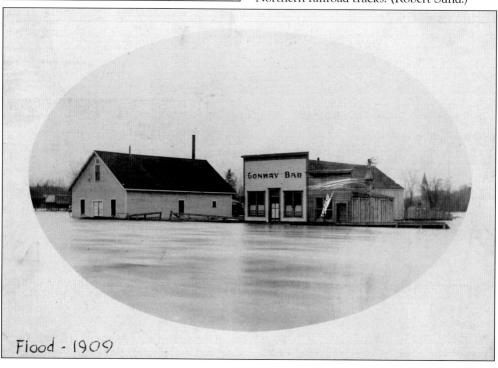

Flood - 1909

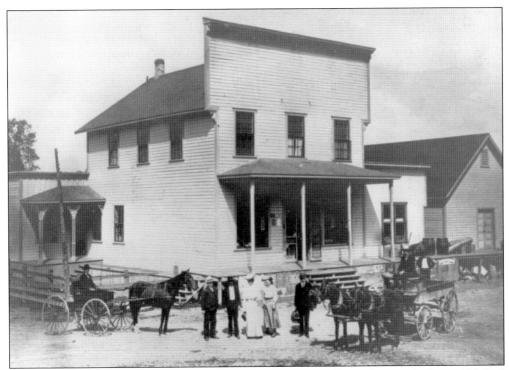

Around 1909, Conway was a growing town with a hotel, a post office, a store, and other established businesses. Visitors could now travel by train, wagon, or horseback to the bustling little town. Travelers gathered at the Conway Hotel west of the train station. The building at right is the hotel warehouse. (Maynard Axelson.)

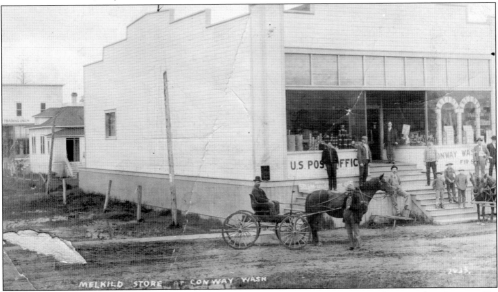

John Melkild owned this store in 1909. The buildings in the background at left are the Conway-Fir Trading Union and William Sund's house. Signs below the two big windows of the store say "U.S. Post Office" and "Conway, Wash, Fir Station." Melkild had a thriving business. This photograph was taken from the area where the train station was located. (Maynard Axelson.)

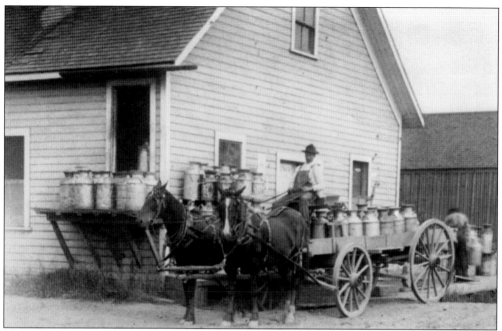

John S. Finstad and Peter K. Utgard opened the Finstad and Utgard Creamery in 1904. A creamery driver would head out with a horse-drawn wagon to deliver empty milk cans to the farmers. He would then pick up cans of fresh milk at the farms and take them to the creamery for processing. (Janet K. Utgard.)

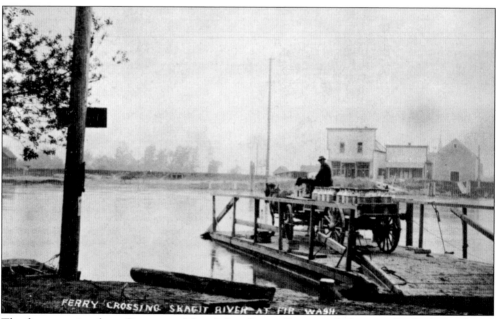

The ferry crossing from Conway to Mann's Landing at Fir was a daily route for the horse-drawn wagon hauling milk cans to and from local farmers. In this photograph looking west, the milk wagon from the creamery is waiting to make the crossing. Ole J. Borseth's store and other buildings at Fir are visible across the river. (Stuart Lange.)

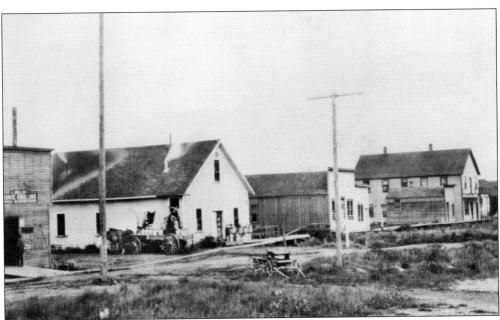

The northwest-facing c. 1911 photograph above shows, from left to right, the blacksmith shop, Finstad and Utgard Creamery, and the old Conway Bar building. The other buildings are unidentified. John S. Finstad and Peter K. Utgard had one of the most successful manufacturing plants in the Puget Sound region. Finstad was in charge and employed expert workmen using the most modern equipment. Workers were kept busy in the plant, and their butter and other dairy products were of the highest grade. Their *primost* was thought to be the best in the world. Walt Wollan was an expert in making primost and cottage cheese. Pictured below from left to right are Finstad, Wollan, and Dewey Utgard. (Above, Robert Sund; below, Arlyne Brodland Wollan and Larry C. Wollan.)

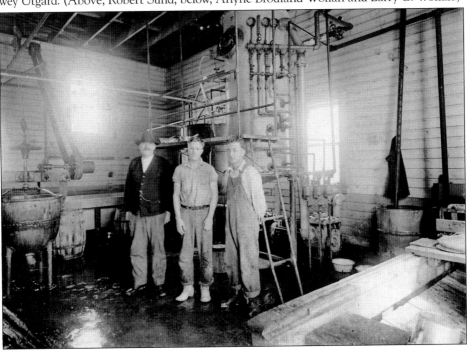

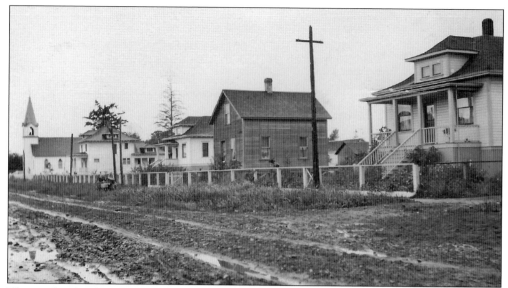

The north side of Main Street is clearly shown in this early 1900s photograph. From left to right are the Conway Norwegian Evangelical Lutheran church and the homes of John and Mary Finstad, Algot and Mabel Johnson, unidentified, and Clifford and Signe Lange. (Solveig M. Lee.)

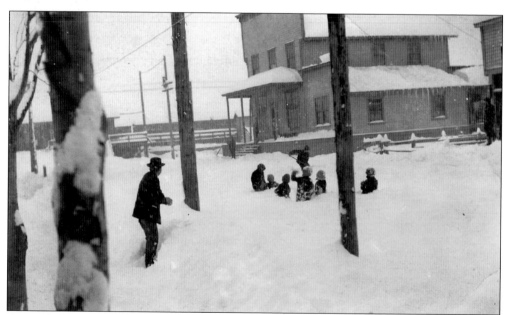

A snowball fight is about to begin in this early 1900s photograph. One boy is shoveling snow from the street as others watch and play in the snow near the Conway Hotel. The train station is in the background at left. (Janet K. Utgard.)

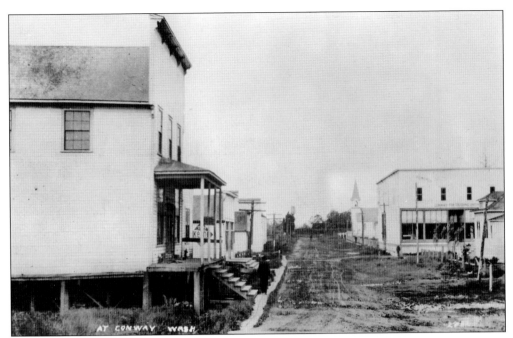

In this early 1900s picture looking west down Conway's Main Street, the large building at right is the Conway-Fir Trading Union, which was next to the home of Bill Sund Sr. Oliver "Ollie" Wollan owned the Conway Hotel (left foreground), which had a pool hall. The pool hall was later located in the building on the other side of the hotel. (Robert Sund.)

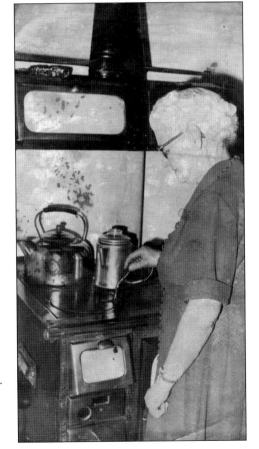

Hannah Swanson was an excellent cook. She married Oliver "Ollie" Wollan on January 10, 1905, and they had five children: Myrtle, Walter, Arthur "Archie," Francis B., and Madell. Hannah is shown cooking on the stove in the Conway Hotel kitchen, which she still had and cooked on up to her death in 1966. (Arlyne Brodland Wollan and Larry C. Wollan.)

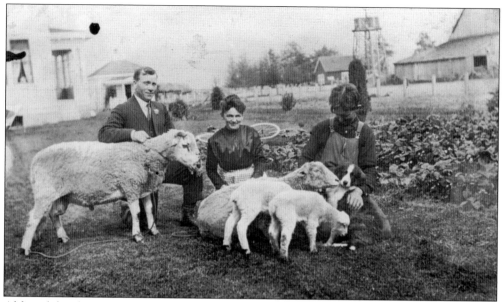

Although locals often ate mutton and lamb, sheep were primarily raised for wool. After the sheep were sheared, the wool was washed and spun into fibers, which produced yarn for clothing and other items. Wool clothing was best for warmth. Here, an unidentified man at left kneels beside Nellie I.P. Lee and her brother Peter with two sheep, two young lambs, and a dog around 1900. (Solveig M. Lee.)

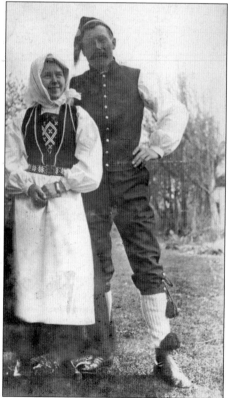

Violet Rygg and Olaf ? are dressed in a traditional style for the Syttende Mai festivities in 1915. Immigrants from Norway would celebrate this anniversary of Norway's independence each year on May 17. Violet was the daughter of Enoch and Julia Rygg. She had several sisters and brothers. Her sister Marie married Clifford Skrondal, and her sister Charlotte married John Skrondal. (Solveig M. Lee.)

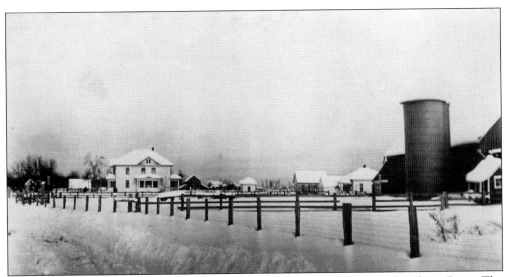

Snow covers the farm of Ole N. Lee north of Conway on the east side of the Skagit River. The house was built by Peder Gjerde and designed by Lee's daughter Nellie. The Lee family raised award-winning Holstein breeding stock on this farm. After Ole N. Lee's death, his children Nellie, Peter, and Oscar continued working the farm. (Solveig M. Lee.)

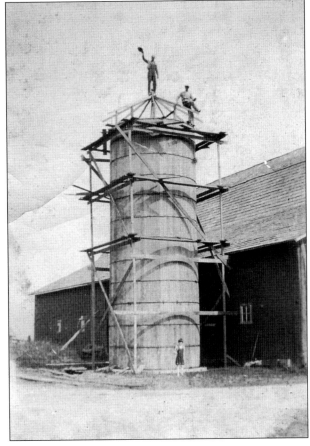

In this c. 1930 photograph, Henry Krangnes (left, waving hat) stands atop his new silo with an unidentified supervisor while young Nellie Handstad watches from below. Grass, or other green fodder, was transferred in through the top of silos without being dried, and in the airtight conditions would become animal feed in the winter. Krangnes family members still live at the site where this farm was located. (Darlene Krangnes, Krangnes family collection.)

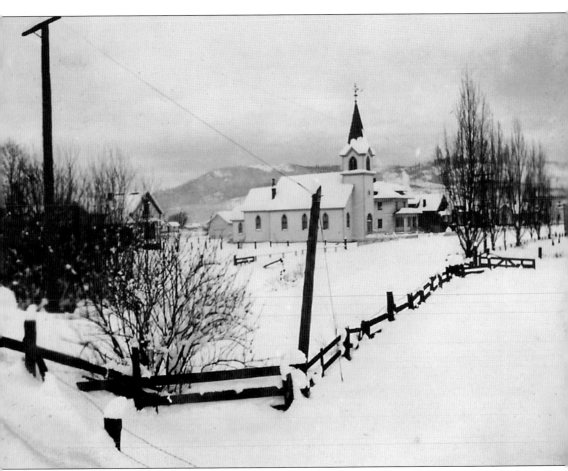

The Conway Norwegian Evangelical Lutheran Church is a pretty sight in this winter scene looking east. The congregation was organized on April 6, 1895, at the Ole Lonke home with Rev. Tobias J. Moen, from Bellingham, as pastor. Reverend Moen ministered until the congregation built this new church in 1905. Mr. and Mrs. Ole Lonke, Mr. and Mrs. Lars Sande, Mr. and Mrs. John Lee, and Mr. and Mrs. Sivert Sande decided to call a new pastor. Rev. E.A. Ericson succeeded Reverend Moen, and then Rev. O.J. Edwards served from 1906 to 1907 and did the altar painting for the church. George Larson followed, then O. Hellstvedt, Rev. A.E. Moes, Rev. G.N. Isolany (who served from 1913 to 1916), and E.B. Slettedahl (who ministered until 1917). In 1917, the church merged with the newly built Fir church on Fir Island. The Conway Norwegian Evangelical Lutheran Church building would later become home to the Conway Fire Department. (Janet K. Utgard.)

March 25, 1918

At the first meeting of the Dike Commissioners of Diking District #18, N. Ostrander, John Wylie and Alger Moberg were present. It was moved and seconded to elect N. Ostrander Chairman and Alger Moberg Secretary after calling for a vote they were both declared elected to office. A notice of this election was signed by the commissioners and mailed to the County Auditor.

N. Ostrander
John Wylie
Alger Moberg

After several years of serious flooding at Fir Island and Conway, locals held a meeting to organize Dike District No. 18. The first meeting of commissioners was held on March 25, 1918, and an election resulted in N. Ostrander being elected as chairman and Alger Moberg elected as secretary. (Dallas R. Wylie.)

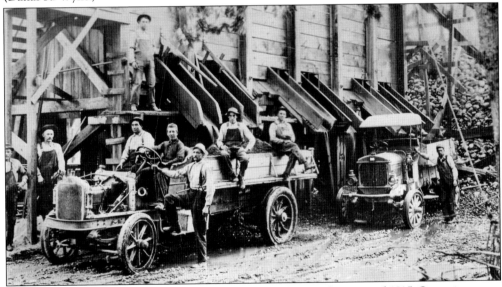

Many men were needed during the time this photograph was taken around 1915. Operations were necessary to haul gravel to build roads and dikes around Conway, Milltown, and Fir Island. Due to flooding over the years, this type of operation would become something that occurred much too often. (Howard "Bud" Tronsdal.)

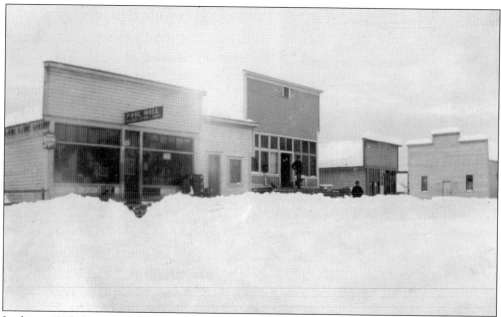

In this c. 1915 photograph looking southwest, from left to right are the pool hall, an unidentified building, an unidentified store, and the Conway Meat Market. These buildings were replaced by the Sund Building. The building at far right was later a roller rink and then became the Conway Auto Company. It was demolished around 1960. The hardwood flooring was saved by Norman Brodland and used in Arlyne and Larry C. Wollan's home. (Janet K. Utgard.)

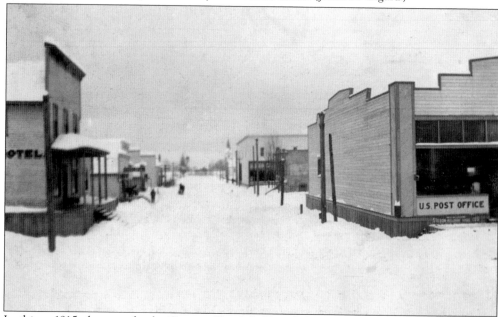

In this c. 1915 photograph, the Conway Hotel (left) and the pool hall are on the south side of Main Street. The post office (right) is in John Melkild's store across the street. Looking west behind the post office are the newly built First National Bank of Conway and the Conway-Fir Trading Union. The steeple of the Conway Norwegian Evangelical Lutheran Church is visible at the end of the street. (Janet K. Utgard.)

Clifford Skrondal married Marie Rygg on October 25, 1916. Clifford worked in John Melkild's store before his brother John, a fisherman, joined him and they began Skrondal Brothers General Merchandise in 1918. The store was a large and modern trading establishment and was a credit to the men who started the business. (Solveig M. Lee.)

John Skrondal eventually became sole owner of the store he opened with his brother Clifford in 1918. John is pictured here with his valuable employee Signe Berg, who married Clifford Lange. At the time this photograph was taken, around 1928, the post office was in the store. The blacksmith shop is barely visible at right. The Fir train station was behind the photographer. This building became Conway Motors and Machine in the 1950s. (Stuart Lange.)

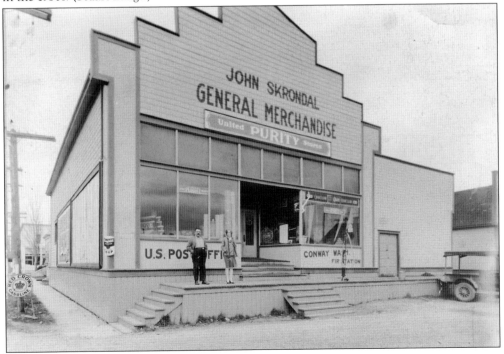

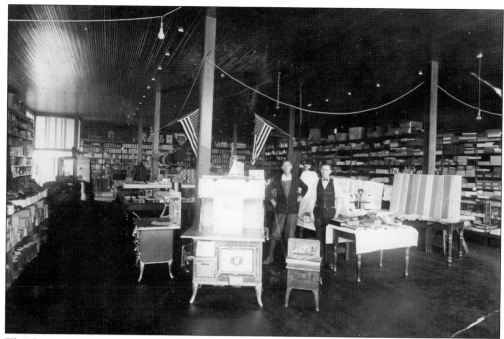

The Conway-Fir Trading Union was managed by George Foss, and in 1924, Robert Hanstad and Sivert Ranes owned the store. Other businesses followed: Ranes and Company, Edwin Sande's Mercantile, and Bergstrom's Hardware. Pictured here are Henry Nystroe (left) and Sivert Ranes preparing for the grand opening of Ranes and Company. (Arlyne Brodland Wollan and Larry C. Wollan.)

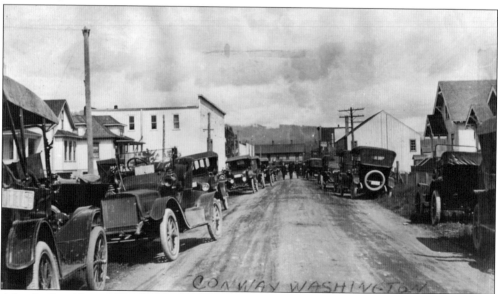

After the First National Bank of Conway opened in 1915, Conway was a busy town. Those involved in the bank were John S. Finstad (president), John L. Melkild (vice president), Abel Garborg (cashier), and Arne W. Garborg (assistant cashier). The bank closed on January 30, 1934, after difficult times following the Depression. The train station is visible at center, at the end of the street to the east. (Solveig M. Lee.)

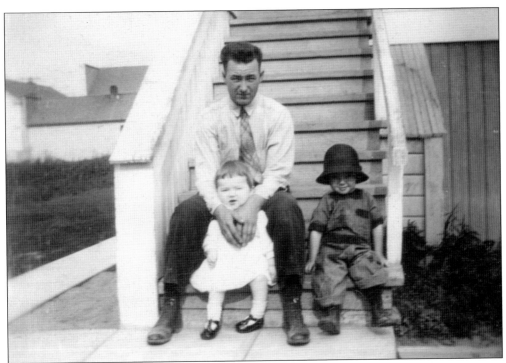

In the c. 1923 image above, Dewey Utgard sits on the steps at his home with two of his children, Dolores and Marvin "Bud" Utgard. Dewey owned and operated Dewey's Service Station on the east side of Old Highway 99 on the corner of the road to McMurray. At right is Dewey's personal letter advertising the Wayne Model 60 gas pump installed at his station and explaining what a "mechanical marvel" the new pump was. It did all of the necessary calculating, and Utgard hoped that the letter would encourage customers to come and try it. Dewey was married to Clara Berg, daughter of Ole Berg, who was the brother of Ole James Berg. Dewey's nephew, Elmer Berg, ran the station on the west side of Highway 99, Berg and Hegeberg's. (Above, Janet K. Utgard; right, Margaret Utgard.)

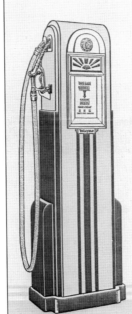

DEWEY'S SERVICE STATION

E. Conway

Conway, Wash.

Dear Sir:

Have you noticed our new streamline model Wayne Computing Pumps? Look for them next time you pass this way! Stop a minute — just see them operate! Then you'll appreciate what an amazing mechanical marvel this pump that calculates your bill while we fill your tank really is.

No waiting, no figuring, no mental calisthenics, no mistakes. The mechanism is automatically synchronized with the posted price plainly shown on the dial. The computation is right, and it's in plain figures before your eyes, increasing as the tank is filled.

When you drive up to one of these pumps, you can say "A dollar's worth", "5 gallons", or "Fill it up!" When the delivery is completed, the dial will show you the total gallons dispensed, including fractional parts, if any, and the total cost to you in dollars and cents. There is no chance of error, for before we serve you, we must set all numbers back to zero or the gasoline will not flow.

We have installed the newest Wayne Model 60 Computing Pumps because they are designed primarily with your protection and convenience in mind.

We'd be mighty glad to have you come in, inspect our station, and watch these pumps operate, whether you buy anything or not.

Yours very truly,

Dewey Utgard

WAYNE MODEL 60

COMPUTING AND RECORDING PUMP

THE WORLD'S MOST EFFICIENT GASOLINE SALESMA

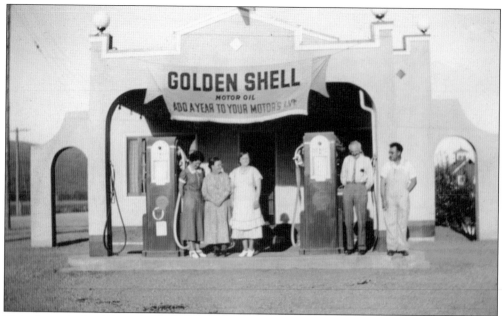

This photograph of Dewey's Service Station was taken in 1936. The station was located on the east side of Old Highway 99 and later became the home of the Turkey House café. Pictured in front of the station are, from left to right, Olive Utgard, Carrie Utgard, Clara Berg Utgard, Brady Utgard, and Dewey Utgard. (Margaret Utgard.)

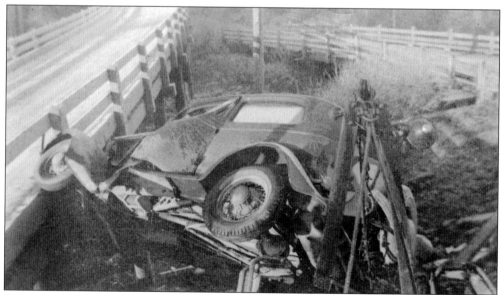

This wreck on the northeast corner of the Fir-Conway bridge in this c. 1930 photograph appears to be a bad one. The original bridge to Fir is at left; the other bridge at right went underneath it to the Sund farm, where the slaughterhouse was located. (Curt Tronsdal.)

Looking east around the 1930s, Peggy Wollan stands in the alley between the blacksmith shop (far right) and the building she and her husband, Walt Wollan, lived in. Elmer Nord and Sid Bruce worked as blacksmiths at Conway. Peggy came to America from Prussia. (Arlyne Brodland Wollan and Larry C. Wollan.)

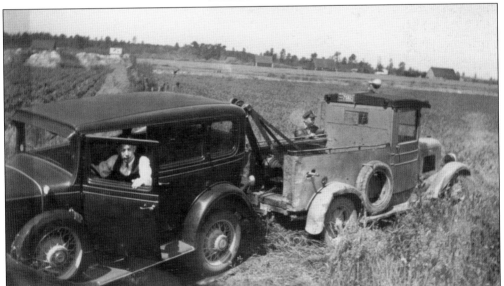

Soft roads on farms and around fields managed to stop this unidentified driver from further travel around 1940. The tow truck arrived with cable, winch, and hook and pulled the driver to hard ground so he could be on his way. (Curt Tronsdal.)

45

Ole C. Noste owned a paint store in the Sund Building for many years. After the store was closed, Noste ran his paint business out of the back of his home and was always known as an excellent businessman. Noste also served as postmaster for many years. He provided quality service and was highly respected in the community. (Dorothy Noste Johnson.)

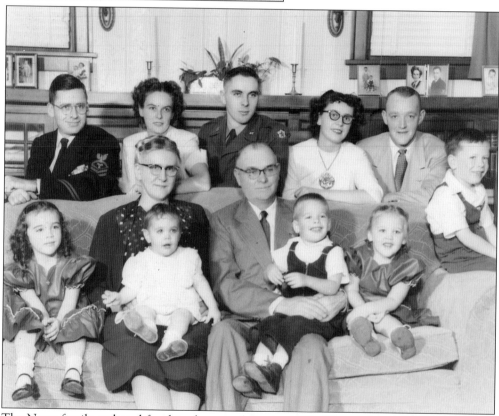

The Noste family gathered for this photograph in the 1950s. From left to right are (first row) Christie Lynn Johnson Gage, Clara Borseth Noste (holding Carol Ann Johnson), Ole C. Noste (holding Michael Johnson), Patricia Jean Johnson, and Charles David Johnson; (second row) Charles V. Johnson, Margaret Louise Noste Johnson, Oliver C. Noste, Dorothy Helen Noste Johnson, and Walter A. Johnson Sr. (Dorothy Noste Johnson.)

46

The Walt Wollan family saved this 1935 calendar from Wollan's Duck Inn Tavern wishing "season's greetings." The tavern was located on the east side of the railroad tracks at the current northwest corner of Main Street and Jones Road. After the tavern closed, the building was later moved south to the Stanwood area and still exists today as a duck-hunting shack. (Larry C. Wollan.)

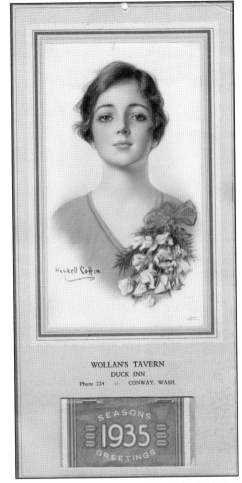

Bill McClusky and his canine assistant traveled together as McClusky worked for the Washington State Patrol in the 1940s. McClusky and some fellow patrolmen owned Skagit Trails, a restaurant and dance hall between Highway 99 and Pioneer Highway. Skagit Trails burned down around 1947. (Curt Tronsdal.)

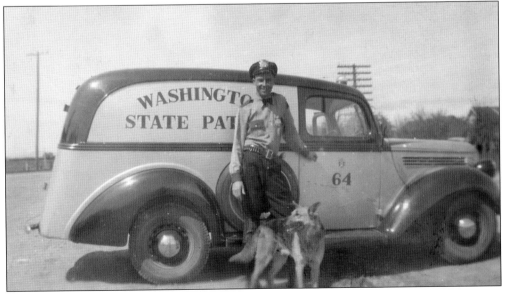

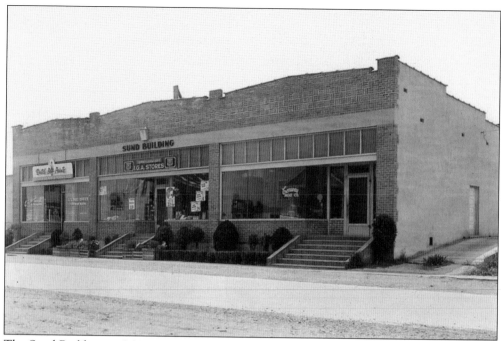

The Sund Building on Main Street was owned by Bill Sund Sr. As shown in this picture from the 1940s, businesses operating around that time included Ole C. Noste's paint store, the post office, the I.G.A. store, and the Conway Meat Market. Early grocery owners were Bill Sund Jr. and Axel Christiansen. Rupert Pleas Sr. had the store, meat market, and a locker plant with cold storage from 1951 through 1956. (Robert Sund.)

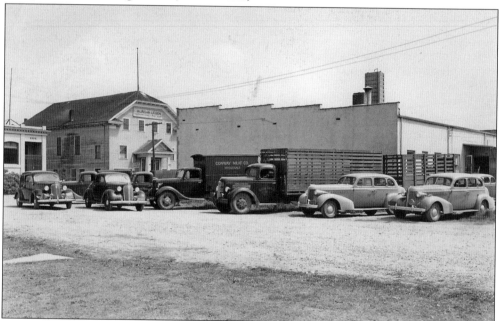

Looking northeast around 1940, both the (closed) First National Bank of Conway (at left) and the American Legion Hall are visible on the north side of Main Street. Delivery trucks are parked at the west end of the Sund Building, where a locker plant was later located. (Robert Sund.)

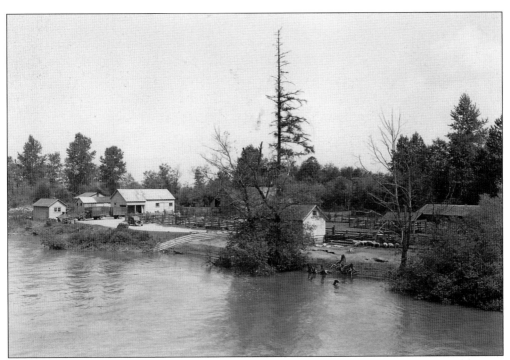

Bill Sund Sr. owned the farm and slaughterhouse north of the bridge on the east side of the river. The buildings shown here are, from left to right, Sund's fishing cabin, the slaughterhouse and meat packing plant, the barn (behind the tree), the granary, and loafing sheds. Pigs (visible next to the granary) and other animals were raised here, but the Sund family lived in town. The barn still stands today. (Robert Sund.)

The American Legion Hall, Mason-McConkey Post, had a tavern built in the lower left corner of the building. John Tellesbo was first to run the tavern in the 1920s. The tavern business has been bought and sold many times. Dances, basketball games, and even some boxing matches were held upstairs, and a barber shop operated here in the 1940s. (Janet K. Utgard.)

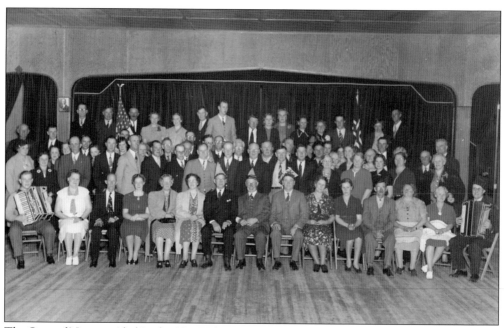

The Sons of Norway Abel Lodge No. 29 began in 1932 with 51 charter members. On December 9, 1932, members Bert Krangnes and G.M. Tideman purchased property from John Setter for $200 and built a two-story lodge, which still stands today. In 1939, Pete and Gertie Bjorgen were honored by a "mock wedding" (below) on their silver wedding anniversary held at the lodge. Those performing were, from left to right, Elwin Hanson, Olaf Locken, Phil Iverson (maid of honor), Dora Anderson Pender (bride), Hannah Wollan (groom), Carroll Severson (minister), Ole Iverson (flower girl), Ragna Berg (ring bearer), Bertha Hanson, Olga Hyde, Leona Weaver, and Inga Utgard. (Above, Robert Sund; below, Sons of Norway Abel Lodge No. 29, Andrew Bjorgen collection.)

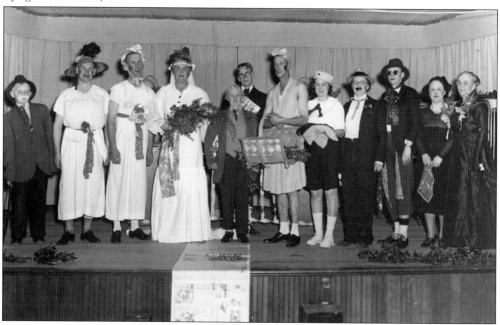

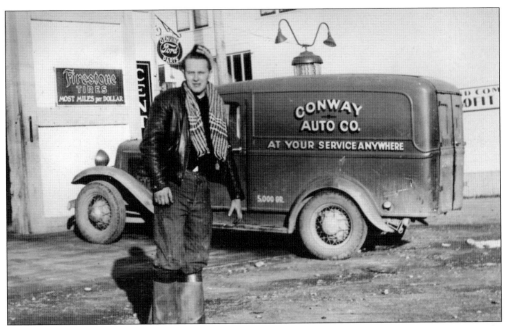

Owen "Tony" Tronsdal stands beside his Ford panel delivery truck in this 1936 photograph. Conway Auto Company was located on the south side of Conway's Main Street prior to Tronsdal going into the service during World War II. He later restarted his repair shop in the old Skrondal general store building on the northeast corner of the street; the new company was named Conway Motors and Machine. (Howard "Bud" Tronsdal.)

The wedding of Tony Tronsdal and Agnes Engen took place at the Fir-Conway Lutheran Church on January 31, 1942. Trondsal's brother Hoff (next to groom) was best man, and Dora Engen Tronsdal (next to bride), Agnes's sister, was maid of honor. The Tronsdal brothers married the Engen sisters. O.E. Heimdal performed both ceremonies. (Curt Tronsdal.)

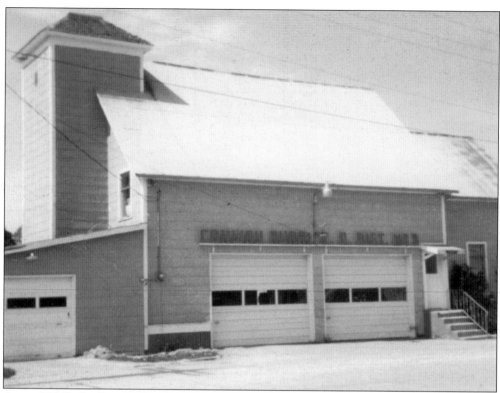

Around 1945, the Conway Rural Fire District No. 3 bought the Conway Norwegian Evangelical Lutheran Church building for use as its fire hall. The firemen volunteered to perform the remodeling work and donated most of the materials. Downstairs was an engine room and a general meeting room. The upper floor housed an office and recreation room. In April 1945, the department ordered a Ford-Seagrave fire truck from the Howard-Cooper Company, at a cost of about $5,000, and began serving the community. About a year after organizing, the firemen joined the county district, becoming Skagit County Fire Protection District No. 3. (Above, Alyne Brodland Wollan and Larry C. Wollan; below, Curt Tronsdal.)

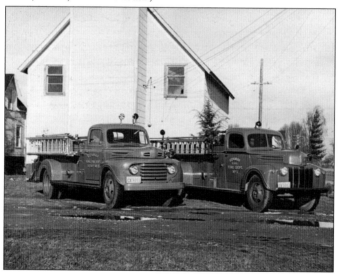

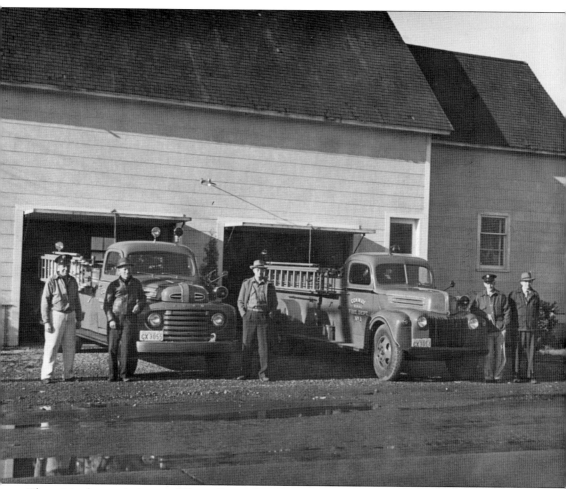

The original commissioners of Skagit County Fire District No. 3 stand in front of the Conway Rural Fire District No. 3's fire hall around 1945. From left to right are Bill Sund Jr. (fireman), Howard Good (commissioner), Hoff Tronsdal (commissioner), Herman Hansen (Conway mayor and first fire commissioner), and Obel Johnson (commissioner). On January 22, 1945, a pre-organization meeting was held at the Sons of Norway Hall, with approximately 50 residents attending, to discuss the much-needed fire department. They decided to formally organize the association. Officers elected were Arne W. Garborg (president), Dan Sundquist (vice president), and Leslie Christensen (secretary-treasurer). Trustees elected were Paul Vike, Gust Holm, Howard Good, Hoff Tronsdal, and Willard Anderson. Those attending the meeting gave $1,000 toward the start of the project. The new district was comprised of the community from Mount Vernon city limits south and east of the river to the Skagit County line, and included Fir Island. (Curt Tronsdal.)

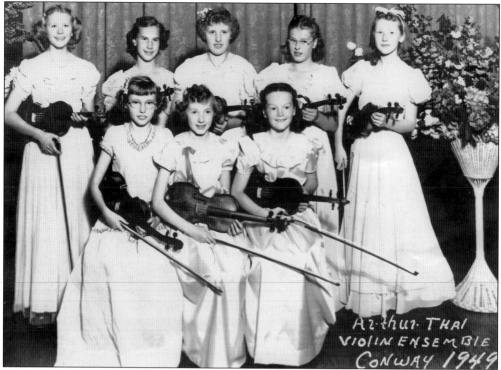

Members of Arthur Thal's all-girl violin ensemble pictured at Conway in 1949 are, from left to right, (first row) Joan Bjorgen, Mary Ellen Flynn, and Elaine Dalseg; (second row) Sylvia Johnson, Anita Clark, Shirley Bjorgen, Arlette Cantrell, and Darlene Rudd. Thal was a master violinist and teacher from Bellingham. (Solveig M. Lee.)

Ole James Berg and Gura "Gina" Sande Berg had four children: Olga, Roy, Signe, and Elmer. Pictured in this 1950s photograph are, from left to right, Ole James Berg, Signe Berg Lange, Pete Hyde (who married Berg's daughter Olga), and Elmer Berg. After arriving on the bow of the *Henry Bailey* in 1891, Berg made his home on the old Wiley place. (Stuart Lange.)

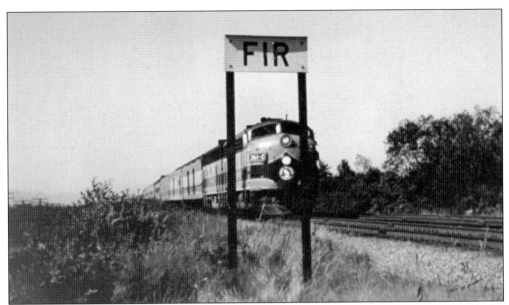

When the Great Northern Railway established its Fir station in 1891, Thomas P. Jones saw an opportunity. He and his wife, Josie, platted the town of Conway (below) in November 1891. After the railroad was established, mail was delivered by train; when the train went by, an incoming mailbag was tossed to the ground, and a trainman used a long-handled hook to retrieve the outgoing bag from a post. Children loved to watch this. Many businesses, later building on the east side of the railroad tracks, became casualties of progress, including Wollan's Duck Inn Tavern, Rainbow Lunch Café, Skagit Trails restaurant and dance hall, Berg and Hegeberg's Service Station, Robert Hanstad's Service Station (later owned by Norman Brodland), and Dewey's Service Station (later home to the Turkey House café). (Above, Arlyn Brodland Wollan and Larry C. Wollan; below, authors' collection.)

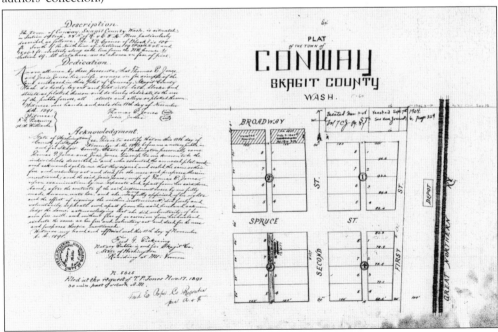

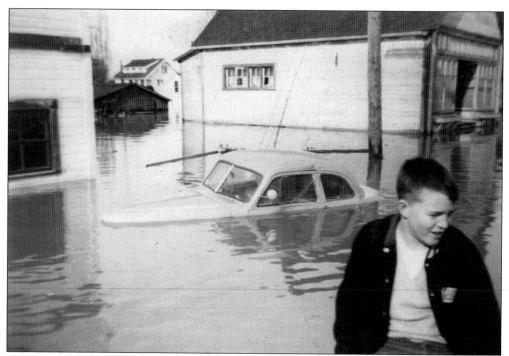

On February 10, 1951, at 7:00 a.m., there was a break in the dike at Noble Lee's on Fir Island, and another break occurred at noon at Conway. Brodland's service station reported 10 inches of water in the station out at the "Y" between Old Highway 99 and Pioneer Highway. In the above photograph, which looks northwest, are Conway Motors and Machine (left) and Arne Garborg's home (background). The building at right was at one time Peggy and Walt Wollans' home. Stuart Lange is sitting in a boat being used to pick up mail from the postmaster, Ole C. Noste. Noste stood on the railroad tracks handing out mail. The image below shows the buildings on the south side of Main Street; they are, from left to right, the Sons of Norway Hall, Ollie and Hannah Wollan's house, and Albert Olson's house. (Both, Stuart Lange.)

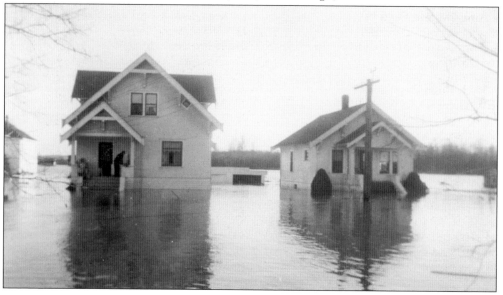

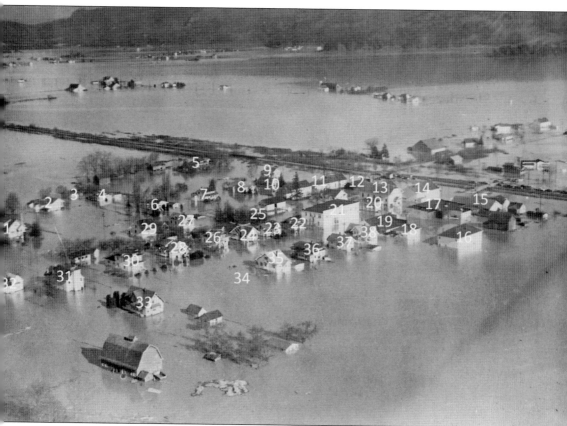

This photograph taken during the 1951 flood shows the locations of some homes and businesses:

1. Bill/Jennie Sund
2. Chris/Bertha Hanson
3. Walt/Peggy Wollan
4. Alfred/Minnie Sund
5. Donald/Nellie Danielson
6. Elmer Nord, the blacksmith
7. A. Garborg
8. Pete/Inga Utgard
9. Paddy Ruski
10. Hallum
11. Finstad and Utgard Creamery
12. blacksmith shop
13. Legion Hall
14. Skrondal's store
15. Axel Christiansen's store
16. Sons of Norway Hall
17. Sund Building (Ole Noste Paint Store, post office, IGA store, meat market, and locker plant
18. Bill Sund Jr.
19. Conway Motors and Machine
20. First National Bank of Conway
21. Conway-Fir Trading Union building with apartments (Sivert/Ruth Ranes, Jim Krangnes)
22. Clifford/Signe Lange
23. Ed Nygaard
24. Ole/Clara Noste
25. Henry Nitroe
26. Algot/Mabel Johnson
27. Ben Tieset
28. John Melkild
29. Pete/Oline Rindal
30. John/Mary Finstad
31. fire department (old Conway church)
32. Pete/Olga Hyde
33. John Setter farm
34. Gus Tideman (after flood)
35. John Bjorkness
36. Andrew/Selma Bjorgen
37. Alberg Olson
38. Ollie/Hannah Wollan. (Stuart Lange.)

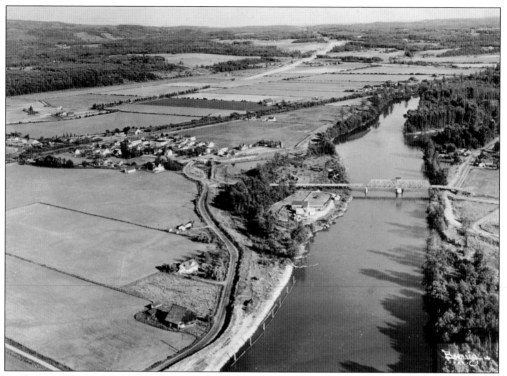

Looking south in this 1950s photograph, the new freeway work for Interstate 5 is visible at top center, and Pioneer Highway runs diagonally to the right. Bill Sund's farm is visible below the bridge on the east (left) bank of the river. The town of Conway is to the left of the bridge. (Arlyne Brodland Wollan and Larry C. Wollan.)

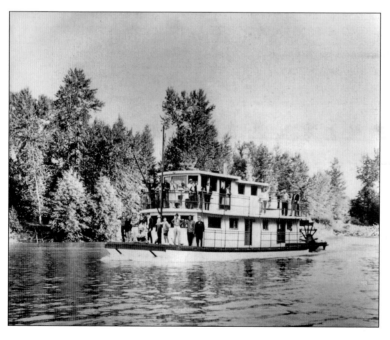

Tony Tronsdal fulfilled a lifelong dream and built a riverboat to replicate those of days past. It took him seven years to complete. His friend Howard Boling built the hull. Tronsdal named the stern-wheeler the *John Edward*, after his son, and installed a kitchen for his wife, Agnes. Several public excursions were held on the Skagit and Snohomish Rivers. (Robert Sund.)

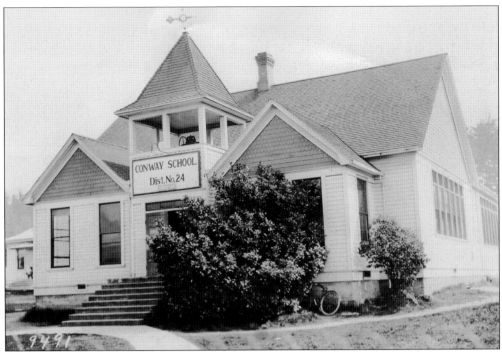

Around 1904, Bert Anderson, John Locken, and P.J. Holt made the initial effort to establish a school at Conway. The earliest attendance records are dated 1905. In 1938, Fir, Milltown, Cedardale, Lake McMurray, and Meadow schools consolidated with Conway School District No. 24, and they all became School District No. 317. Skagit City held out for a year but in 1939 consolidated with the others. The above photograph was taken in the 1940s, and the sign over the school entrance still says Conway School District No. 24. Below, unidentified students attending Conway school in 1921 pose on the school grounds with a background later found in most school group photographs. (Above, Arlyne Brodland Wollan and Larry C. Wollan; below, Curt Tronsdal.)

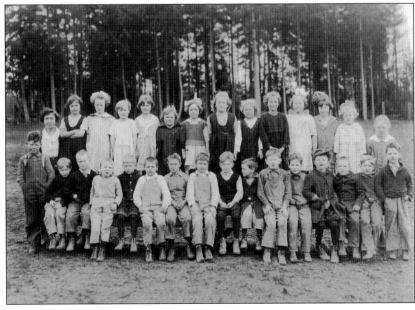

CLASS

EARL ANDERSON
MARGARET ANDERSON
ELMER BERG
HOWARD BOLING
ALBERT BRANDT
BERTIL CARLSON
RAGNA HANSTAD
MILDRED HOLM
OLAF HYTMO
HENRY MANSETH
FLORENCE NEDERLEE
JAMES O'HEARNE
EDYTHE ROSE
ALFRED SUND
HALFDAN TRONSDAL

PROGRAM

PIANO SOLO	RAGNA HANSTAD
SALUTATORY	CLASS PRESIDENT JAMES O'HEARNE
SONG	CLASS
RECITATION	MARGARET ANDERSON
SONG	GRAMMAR GRADE GIRLS
VALEDICTORY	EARL ANDERSON
SONG	CLASS
ADDRESS	DR. E. T. MATHES
PRESENTATION OF DIPLOMAS	MABLE GRAHAM (County Superintendent of Schools)
PIANO SOLO	EDYTHE ROSE

The 1924 Conway School graduation class consisted of Earl Anderson, Margaret Anderson, Elmer Berg, Howard Boling, Albert Brandt, Bertil Carlson, Ragna Hanstad, Mildred Holm, Olaf Hytmo, Henry Mauseth, Florence Nederlee, James O'Hearne, Edythe Rose, Alfred Sund, and Hoff Tronsdal. Hanstad played a piano solo, O'Hearne was class president and salutatorian, M. Anderson did a recitation, the grammar girls sang a song, E. Anderson was valedictorian, Dr. E.T. Mathes gave the address, Skagit County superintendent Mable Graham presented diplomas, Rose also played a piano solo, and the class sang two songs. Pictured below are Conway School baseball team members from around 1924. From left to right are (first row, sitting) Arthur Wollan, Alfred Sund, and Henry Mauseth; (second row, standing) Earl Anderson, Olaf Hytmo, Hoff Tronsdal, coach Lewis G. Nyhus, Elmer Berg, James O'Hearne, and Bertil Carlson. (Above, Curt Tronsdal; below, Howard "Bud" Tronsdal.)

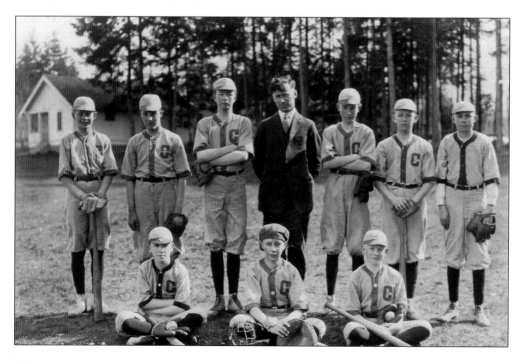

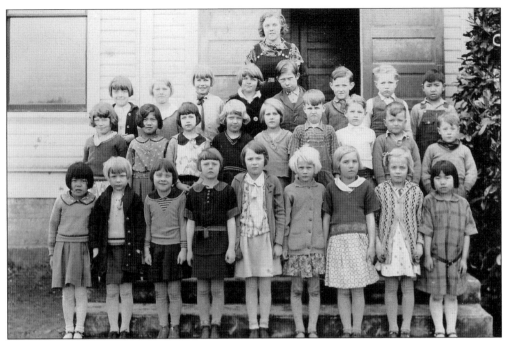

The students pictured above attended first, second, and third grades at Conway School during the school year beginning on August 29, 1932, and ending May 25, 1933. The classes included (first grade) Helen Hall, Hannah Hayano, Magna Sandness, Annette Swanson, Johanna Torseth, Shirley Garborg, Fumeko Osaki, Florence Moe, Johnny Locken, Owen Torseth, and Irving Utgard; (second grade) Laurine Hannaford, Helen Hanson, Helen Husby, Helen Johnson, Lyla Johnson, Elsie Lee Mires, Gladys Rindal, Norma Sinnes, and Leonard Bjorgen; (third grade) Lorraine Hall, Marion Hanson, Mary Hayano, Peggy Husby, Norman Auberg, N. Osaki, Erling Sinnes, and Buddy White. Not all students named are pictured. Their teacher was Dorothy Sollie. The "all class" photograph below was also taken in 1933 at Conway School; however, the students are unidentified. (Above, Margaret Utgard; below, Janet K. Utgard.)

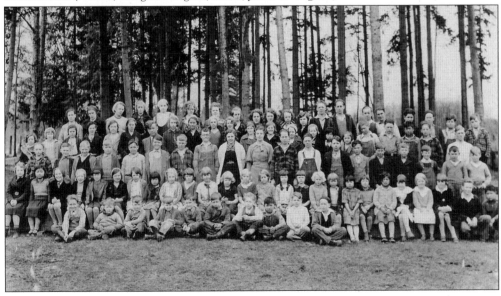

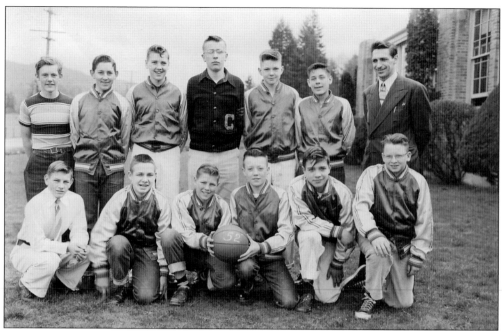

The 1952 basketball team (above) included, from left to right, (first row) Gary Wiles, Carl Nelson, Jim Frey, Roger Dalseg, David Hayton, and Richard "Dick" Barker; (second row) John Manion, Jerry Martin, Wayne Clark, Robert "Bob" Sund, Dave Bromels, Dale Gunerius, and coach Jim Patterson. The Conway School graduating class of 1952 photograph below shows, from left to right, (first row) Peggy Nokleby, Jerry Martin, Dorothy Barker, teacher Jim Patterson, Patsy Olson, ? Parsons, Louise Crookshank, and Roger Dalseg; (second row) Joan Nelson, Howard Strobel, Bette Wollan, Harvey Wolden, Wanda Lee, Earl Curry, Darlene Bradburn, John Manion, and Dena Schorno; (third row) Joan Bjorgen, Deanna Johnson, Jim Frey, Bob Barker, Carl Nelson, Jerald Belcoe, Virgil Adams, and Carol Olson; (fourth row) Robert "Bob" Sund, Sharon Rose Hanson, Wayne Clark, Selma Teiset, and Wayne Winhofer. (Both, Robert "Bob" Sund.)

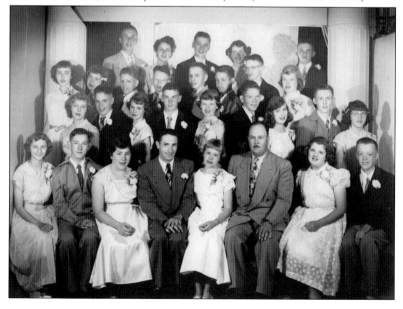

Four

FIR, "MANN'S LANDING"

Mann's Landing, as Fir was first named, had its beginning in the logging industry. When logging began along the Skagit River, many men were needed, so Charles H. Mann opened a store on his claim in 1876, and boats started making stops there.

Shortly thereafter, Mann built a hotel that was kept by Mrs. John Anderson, and ran a post office by himself. Charles F. Treat became postmaster. Two other stores were at Mann's Landing—one owned by Treat and another by Edward Osborne. At that time, Fir was as big as Mount Vernon.

Around 1880, a ferry replaced a scow that crossed the Skagit River between Conway and Mann's Landing.

There were three hotels at Mann's Landing. In 1882, Magnus Anderson replaced Mann's hotel with a two-story hotel north of Mann's store. Charles Villeneuve and his wife took charge of this new hotel. John Anderson owned a hotel south of Mann's store, and Frank Carrin owned the Morling House.

On April 10, 1885, a fire wiped out nearly every building at Mann's Landing. The loss totaled $17,000, with few businesses having insurance. Anderson rebuilt his hotel right away, as did some others.

Eight years later, around 1893, the store buildings were again wiped out by fire with a loss totaling $25,000. Even after this fire, the town continued to survive; however, the economic depression during the 1890s made it difficult.

When the Fir-Conway bridge was built in 1914, Conway was larger than Fir, with only two businesses remaining at Fir: Ole Borseth's store and the Sandness and Tellesbo store, which contained a post office. Borseth's store was moved from the bank of the river soon after to a site across the road from the Fir-Conway Lutheran Church and around the 1920s became Longe and Triber Fir Mercantile Company, owned by Engvald Longe and Earl Triber.

Mann's Landing, once a vibrant trading center, had all but vanished by the 1930s.

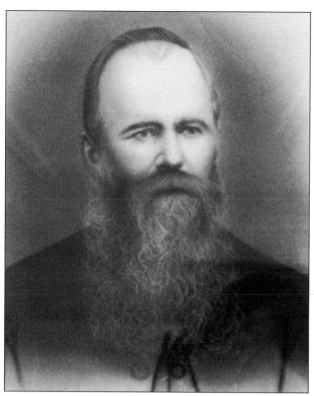

Pictured are Thomas Hayton (1832–1913) and his wife, Sarah Elizabeth Saunders Hayton (1833–1896), who came to Fir with their family in 1876 to make their home. In 1877, their son James Blaine Hayton was born. Previous children of Hayton and Sarah were Jacob, Thomas R., Henry, George W., and Laura M. After James was born in 1877, three more children were born: William, Cora E., and Richard F. Laura M. Hayton married Lewis P. Hemmingway, and daughter Cora E. married Alfred Polson, both men from pioneering families. Sarah died in November 1896, and Thomas lived until 1913. James B. Hayton and his brother-in-law Lewis P. Hemmingway took over the family farm following the death of Thomas. (Both, Susan Hughes-Hayton; Hayton Family Collection.)

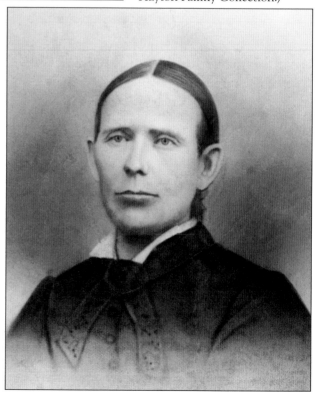

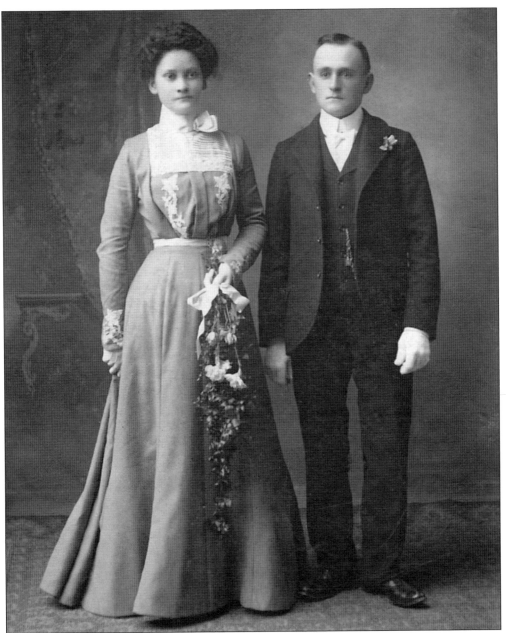

Maud May Good and James Blaine Hayton are pictured on their wedding day—December 25, 1901. Harry Ferguson, a Baptist minister from La Conner, performed the ceremony at Fir. Hayton's parents, Thomas Hayton and Sarah Elizabeth Saunders Hayton, homesteaded on Fir Island, making their home west of Fir in 1876. James was the first child in the family to be born in Washington, and the youngest of eight children at home at the time. In 1928, James Hayton was elected Skagit County commissioner and served in that capacity for two terms. He was an organizer of the Skagit Farm Bureau and was successful in leading the campaign that resulted in building the Deception Pass Bridge. He was also instrumental in building the Memorial Highway west of Mount Vernon and secured the aid of the state in rebuilding the saltwater dikes after the great tide of 1934. (Susan Hughes-Hayton, Hayton family collection.)

Ole J. Borseth (left, 1857–1926) was born in Oksendal, Norway. Borseth came to America in 1882 and later made a home at Fir, becoming a well-known businessman. He had a store on the west bank of the Skagit River, where boats regularly stopped at Mann's Landing to load and unload. Noste married Dordi Furseth (below), also from Oksendal. Upon her arrival to the area, Dordi stayed with the Lars Engen family at Milltown. She and her husband made their first home above the store he owned on the riverbank. Dordi had to carry buckets of water up the stairs to wash her clothes. In all respects, she made motherhood and housekeeping honorable. Dordi died in 1922, four years before the death of her husband. (Both, Dorothy Noste Johnson.)

John Mauseth first lived in this little house, located south of the Hirohito family home, around 1915. Bert Shelde's mother lived here later, followed by Ole C. Noste and Clara Borseth Noste after their marriage. The house was across the road from the Gust Sandness building. (Dorothy Noste Johnson.)

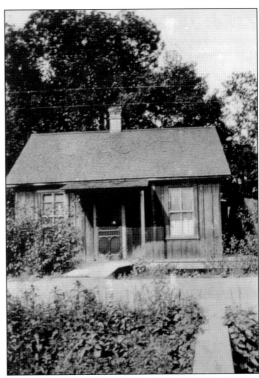

The Ole J. Borseth family sat for this portrait around 1910. Pictured are, from left to right, (first row) Albert Sigurd, Gladys Olena, Edgar "Pete" Melville, and Olivia Dorthea; (second row) Marit Sigfrid, Ole J., John Daniel, Dordi Furseth Borseth, and Ole A; (third row) Clara Dorthe, Bertha Malinda, Mabel Gudrun, and Nils Bernhard. (L. Richard Larson.)

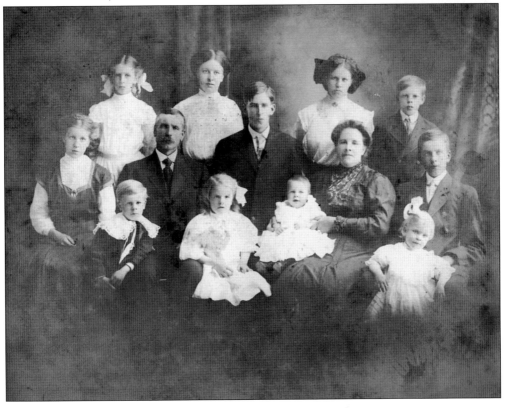

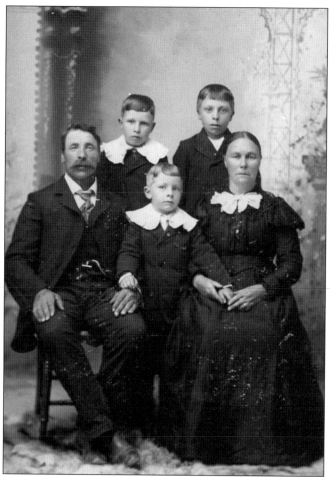

Even Hanstad came to Fir in 1887. His wife, Ragnhild Krangnes Hanstad, arrived from Norway in 1889 with their children—Sivert, Marie, Anton, John, Hans, and Robert. Pictured at left are, from left to right, Even, Eddie, Otto, Robert, and Raghnild. Eddie and Otto were both born at Fir. After selling the family farm of 40 acres on Fir, Hanstad and his wife moved to the east side of the river and made their home at Conway. Below, they are seated near the top of the steps of their newly built home with their grandchildren Ragna and Owen (their son Robert's children). This house still stands today. (Left, Patricia Hanstad Pleas; below, Vicki Carlson Archer, Rose Hanstad Carlson collection.)

The four oldest children of John and Annie K. Hanstad pose in this c. 1911 photograph. Standing from left to right are Rose, Henry, and Evelyn, and John Arnold is seated in the center. All of these children were born on Fir Island. John Arnold was brought into this world at Skagit City with midwife Tillie Larson in attendance. (Patricia Hanstad Pleas.)

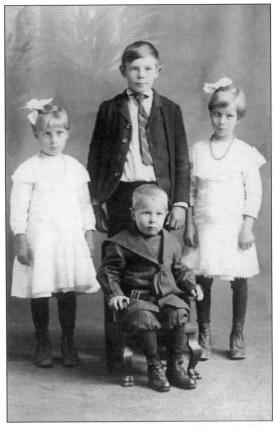

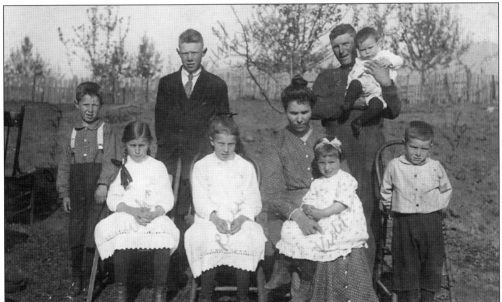

In this c. 1915 picture, the Hanstad family poses in the yard of their home on Fir Island. From left to right are (first row) Evelyn, Rose, Annie K. (with Violet on her lap), and Walter; (second row) John Arnold, Henry, and John (holding baby Mildred). (Patricia Hanstad Pleas.)

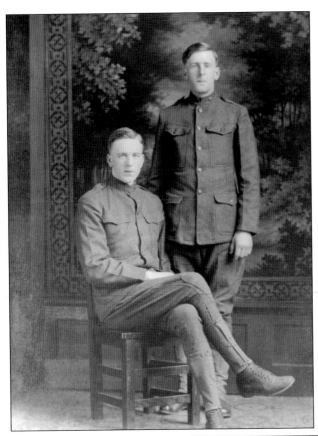

Pictured here around 1919, the Borseth brothers, Ole Alfred (sitting) and John Daniel, both served in World War I. Ole died in 1922. John Daniel was six years older than his brother. After the war, he went off to work, and several years later, the family lost contact with him. Despite many attempts to locate him over the years, whatever happened to him remains a mystery. (L. Richard Larson.)

John D. and Ole A. Borseth's younger brother Nils Bernard was born in 1899. He served with the Navy during World War I. Nils was a fireman aboard the USS *Mercury* and served for three months, from July 1918 to October 1918, as the war came to an end. Nils was a charter member of the Conway American Legion, never married, and died in 1939. (L. Richard Larson.)

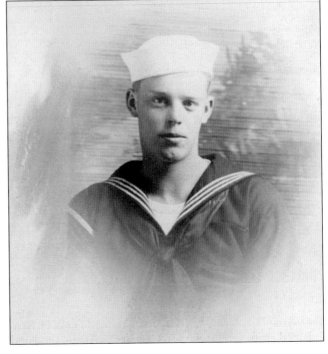

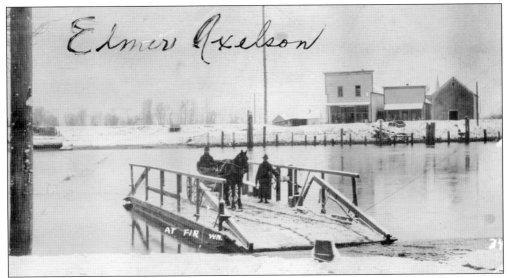

Snow has fallen in this c. 1890s photograph looking west as a horse-drawn wagon makes the journey from Mann's Landing to Conway on the ferry. Not everyone was fortunate enough to have a wagon. Borseth's store and other buildings are visible across the river. (Maynard Axelson.)

This structure, the original home of William "Billy" Lisk, was located on the road to Skagit City. Billy was born in the 1870s and was the son of Joseph Harison Lisk and I-Flugh Caroline Buckskine Lisk. His sister Mary Ann married Frank H. Mann. Billy died on March 7, 1950, and is buried at the Mount Vernon Cemetery. (Arlyne Brodland Wollan.)

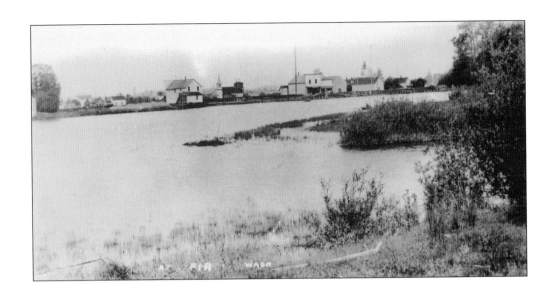

Pictured above looking northwest are the buildings still remaining at Fir in 1910. From left to right are John F. Anderson's home, Ole J. Borseth's original home, the Alex Johnson home, the Sandness and Tellesbo store (center left, on the riverbank), Fir Lutheran Synode Church (steeple), Borseth's windmill, Borseth's store, a saloon (closed), Gus Johnson and John Hanson's granary (later owned by Wilder Bruce), Andrew Crogstad's granary, and the Lathrop house. What appears to be a sand pile to the left of the Sandness and Tellesbo store is where the Morling House burned shortly before this photograph was taken. Pictured below at right moored in front of the two stores mentioned above is the *Gleaner*, a large steam-powered stern-wheeler. Boats would stop at Fir (Mann's Landing) to load and unload people and cargo. A bridge was built in 1914. (Both, Dorothy Noste Johnson.)

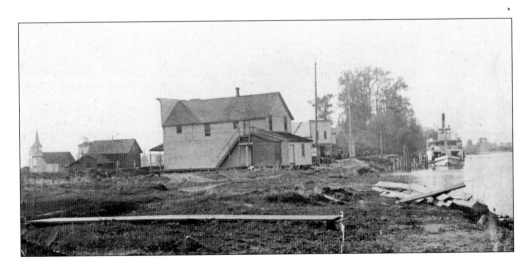

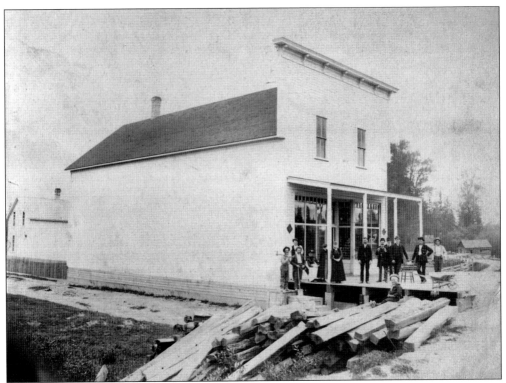

Pictured in the 1890s is Ole J. Borseth's store on the west bank of the south fork near Mann's Landing. A warehouse and granary were built north of the store. (L. Richard Larson.)

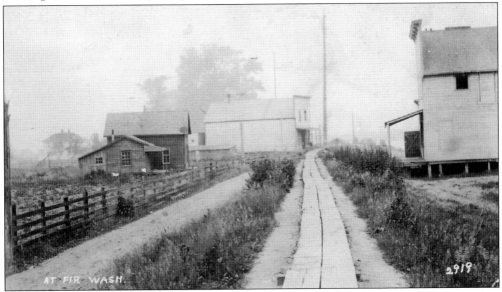

The narrow road and the plank walkway run side by side in this early 1900s photograph taken at Mann's Landing. From left to right are Ole J. Borseth's home (in the background); the little house that had been lived in by Mauseths, Sheldes, and Nostes at different times; an unidentified structure; Borseth's store; and the Sandness and Tellesbo store. (Arlyne Brodland Wollan and Larry C. Wollan.)

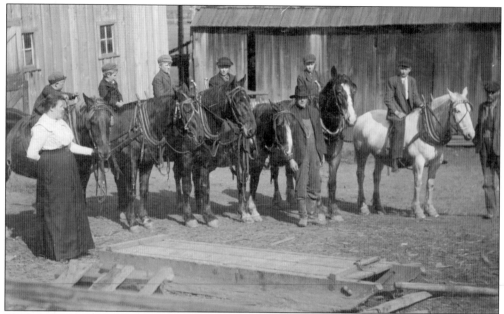

The Brodland family gathers in this c. 1912 photograph as the six Brodland boys sit on horseback beside the barn. From left to right are Regina Brodland (holding the reins for her young son Melvin Brodland), Walter, Norman, George, Hans, Bob, and "G.H." Brodland (standing at far right), the boys' father. The man in the center is unidentified. (Arlyne Brodland Wollan.)

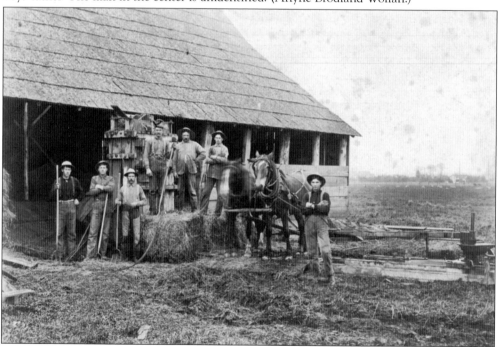

Haying crews used this early baler powered by a yoked team of horses. The men fed the hay into the top of this "windlass" machine. Conrad Axelson (fourth from left) initially worked for his brother Elmer. After a few years, he bought 20 acres of Elmer's land, built a house, and established his own farm. (Maxine Axelson Shroyer.)

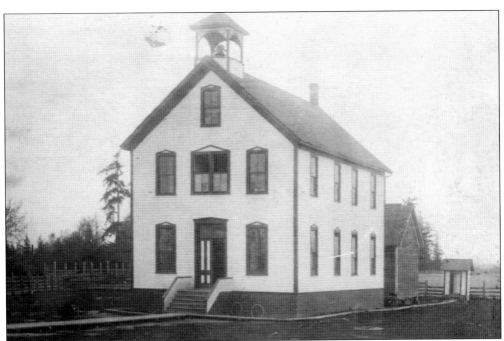

The original Fir School is shown in the c. 1900 photograph above. It sat on property donated by the Andrew N. Crogstad family, about a mile and a half west of Mann's Landing on the Fir Island Road. The final touches are being made to the school addition (below) in 1916. The painters on the scaffold are Donald Danielson and Ole C. Noste. The carpenters on the bannister are John Berkness and Ingemar Hallem. Teacher M.H. Jordan stands at the bottom of the steps. The children are, in no particular order, Arne Olson, Albert Borseth, Edgar Borseth, Nels Hegeberg, Elmer Hegeberg, and Gladys Borseth. Other children known to attend the school around 1916 were Henry, Rose, Evelyn, and John Arnold Hanstad. Crogstad owned the house in the background. (Above, Diana Tingley Weppler; below, Arlyne Brodland Wollan and Larry C. Wollan.)

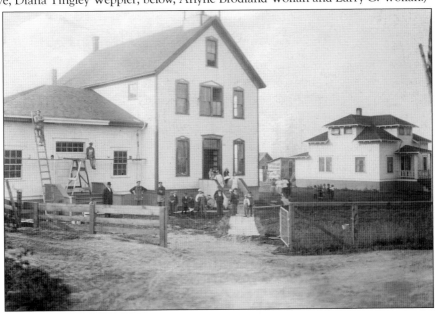

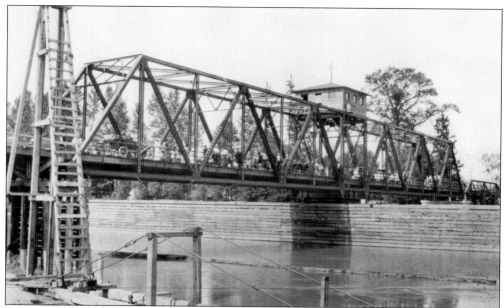

July 4, 1914, marked the opening day of the new bridge between Conway and Fir Island that replaced the ferry crossing. The first car across the bridge, a Winton Six, belonged to Mr. Kimble, the bridge builder, followed by teams of horses. Controls in the building atop the bridge were operated by the bridge-tender, who opened the bridge for tall boats. (Dorothy Noste Johnson.)

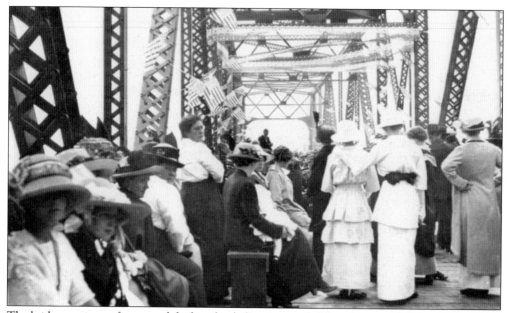

The bridge was in use for a month before the dedication was held on August 15, 1914. Among those pictured at the dedication are Constance and Lillian Isolany, Mrs. Ed Eisen, Martha Peterson, and Mrs. Beek. The woman sitting on a bench holding a child is Mary Skjervem Nyhus. Reverend Heimdahl addressed the crowd. (Dorothy Noste Johnson.)

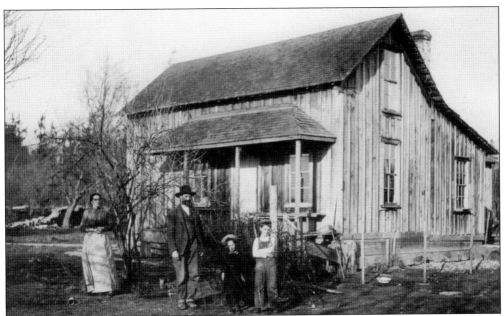

The Husby family stands in front of their little island home in the early 1900s. From left to right are Randi, Erik P., Gunvor, and Henrik. After the house was remodeled in 1927, Norman and Carrie Hanseth Brodland bought the house and farm in 1937, raising their children Connie, Arlyne, George, and Bobby. The house, later moved off the island by Arne Olson, now stands as part of the Percival home on Mann Road. (Arlyne Brodland Wollan.)

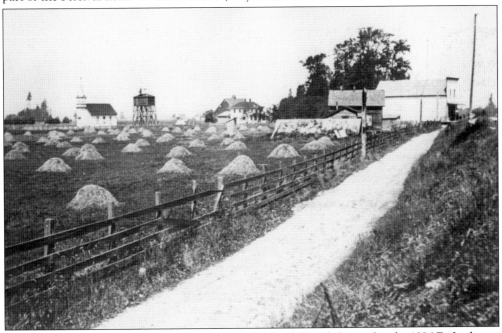

This early 1900s photograph shows Borseth's hayfield and, from left to right, the 1896 Fir Lutheran Synode Church, Borseth's windmill, Borseth's newer home and barn, the root house for potato storage, the Hirohito home (called the "Red House" because it was painted red), and the Borseth store. Note the narrow road. (Dorothy Noste Johnson.)

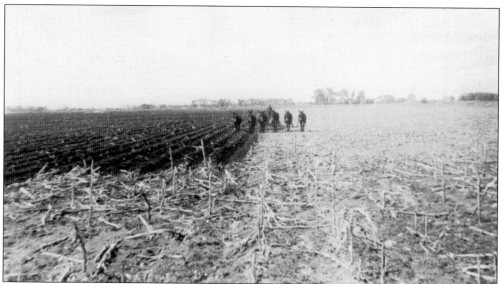

Elmer Axelson grew corn on his farm for cattle feed and used this team of six mules to plow a field on his Fir Island farm. Farmers utilized mules because they were intelligent, dependable, and had an even stride. They were also easy to maintain. (Maynard Axelson.)

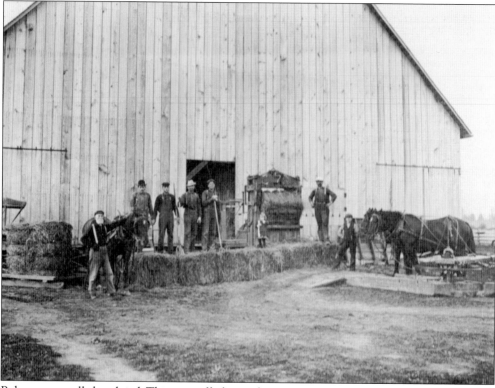

Bales were usually hand tied. This type of baler used string or wire, compressing the bales for better storage. Workers on the Elmer Axelson farm baled hay brought in from the fields to a stationary baler. Hay would be loaded into the baler with pitchforks as horses walked in a circle hitched to machinery driving power to the baler. (Maynard Axelson.)

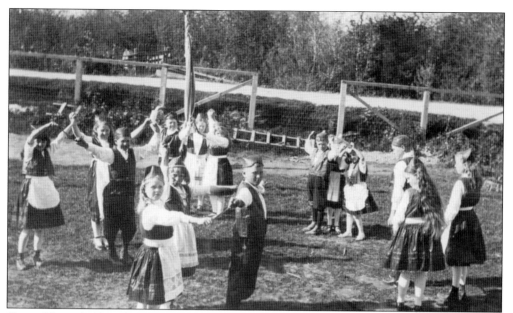

Carrie Hanseth (front left center) and Norman Brodland (front right center) hold hands during this May 17 Norwegian celebration at the Fir School in 1913. These two youngsters continued to be sweethearts and were married on November 3, 1928, with O.E. Heimdahl officiating. (Arlyne Brodland Wollan.)

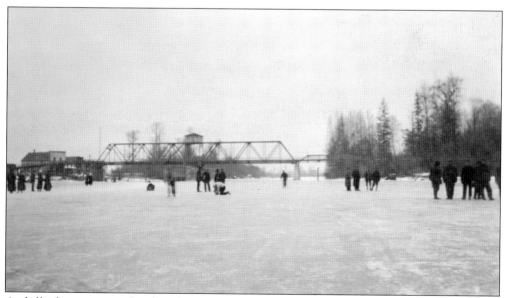

A chilly day greets residents in this c. 1915 image looking north over the frozen Skagit River between Fir Island and Conway. Residents took time to enjoy the ice, with several putting on their skates. This is the last known time the Skagit River froze. (Janet K. Utgard.)

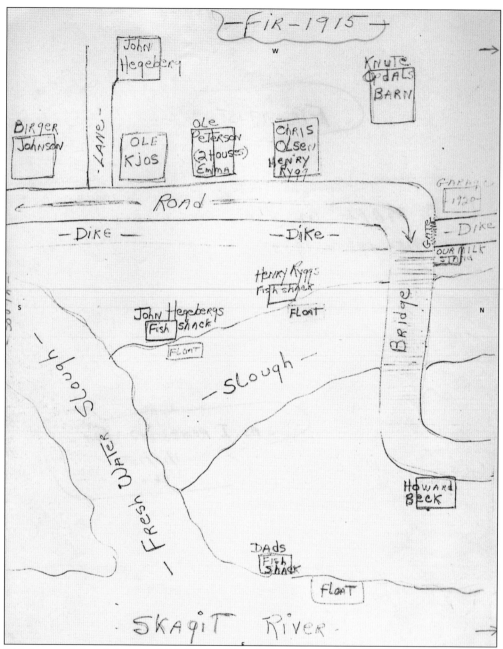

This is part of a hand-drawn c. 1915 sketch of Fir at "Mann's Landing" by Carrie Hanseth Brodland. It gives the locations of homes of Birger Johnson, John Hegeberg, Ole Kjos, Ole Peterson, Emma Peterson, Chris Olsen, and Henry Rygg. Howard Beck's home is on the inside of the dike. Knute Opdahl's barn is between the Olsen and Rygg house, and the home of the Peter Hanseth family. Locations of the fish shacks owned by John Hegeberg, Henry Rygg, and Peter Hanseth ("Dads") are also shown on the inside of the dike. The Skagit River runs north (left) and south, and the Kickialli Slough, named after the Kikiallus Indian tribe, flows off of Fresh Water Slough. The fish shacks are on the inside of the dike and a bridge is over Kickialli Slough. (Vicki Carlson Archer; Rose Hanstad Carlson collection.)

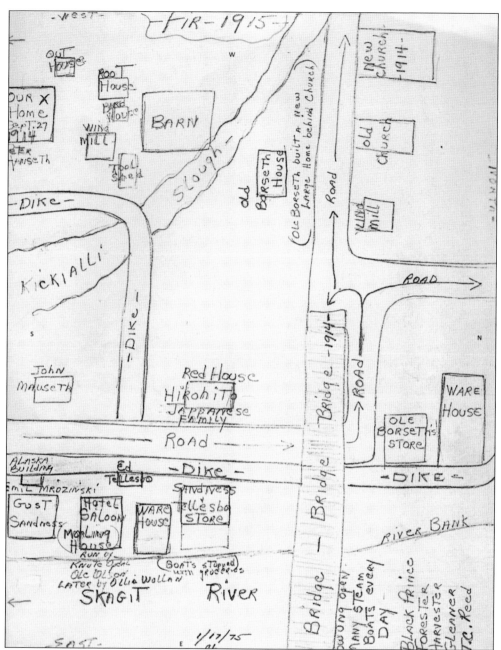

The other half of Brodland's 1915 sketch shows Peter Hanseth's home, outhouse, root house, birdhouse, windmill, tool house, and barn. Ole J. Borseth's old house is across the street from the two churches and his windmill. John Mauseth's house is east of the Kickialli Slough, and the Hirohito family home (the "Red House") is between the dike and the two roads. The 1914 bridge is completed and the road to Mann's Landing turns right and around, going under the bridge. Borseth's store is still on the dike next to his warehouse. The Alaska Building (owned by Emil Mrozinski), Gust Sandness's building, the Morling House, warehouse, and the Sandness and Tellesbo store are all visible on the riverbank. (Vicki Carlson Archer; Rose Hanstad Carlson collection.)

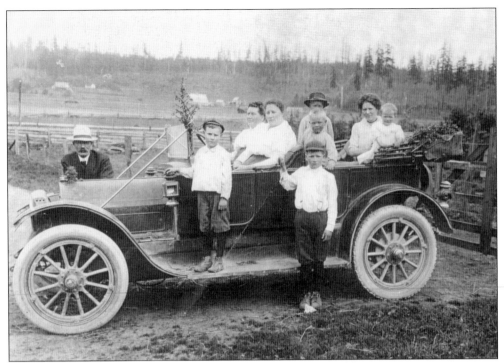

G.H. Brodland (far left) stands beside a touring car in this c. 1914 image. His wife, Regina, is in the driver's seat with her sister Anna Woll beside her. Walt Brodland stands on the running board near brother Norman Brodland (standing on the ground). Their younger brother Melvin Brodland is behind Norman in the car. All others are unidentified. (Arlyne Brodland Wollan.)

These Fir Island girls, pictured around 1928, are having some fun sitting on this roadster in front of the Sandness building. Geraldine "Pully" Sandness (left) and Carrie Hanseth are sitting on the roof of the car, while Vera Anderson (left) and Thelma Hanseth are seated on the rumble seat lid. (Arlyne Brodland Wollan.)

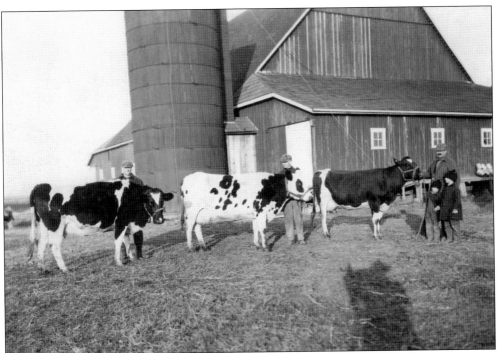

Elmer Axelson's Holstein cattle were some of the earliest registered in the area. In this c. 1920 photograph, Axelson is standing at right with his two young sons Russell (left) and Emanuel. The other two men are unidentified farm workers. (Maynard Axelson.)

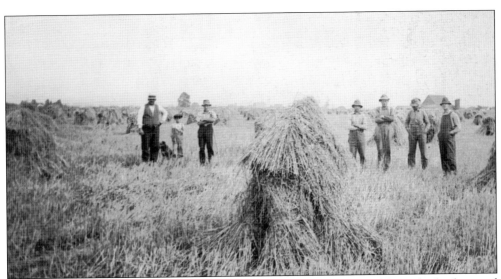

In this c. 1923 photograph looking south, Elmer Axelson's barn is visible in the background at right. Axelson is standing at left with unidentified workers. Oats were put into shocks to be threshed and bagged. Bags were loaded on the steamboat at Browns Slough and taken to Seattle. Some of these oats were destined for Seattle police horses. (Maynard Axelson.)

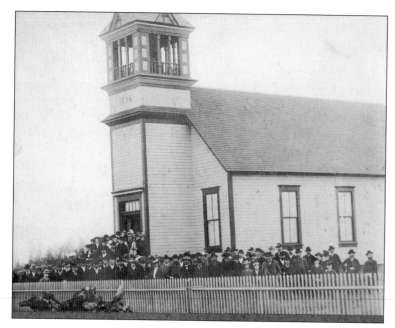

Alex Johnson's home, windmill, and barn are barely visible in the distance at far left. The Fir Lutheran Synode Church, built in 1896, purchased this property from Johnson. The Fir Island road runs east and west along the church fence. The first wedding held at the church was that of John Hanstad and Annie K. Olson in 1901. (Dorothy Noste Johnson.)

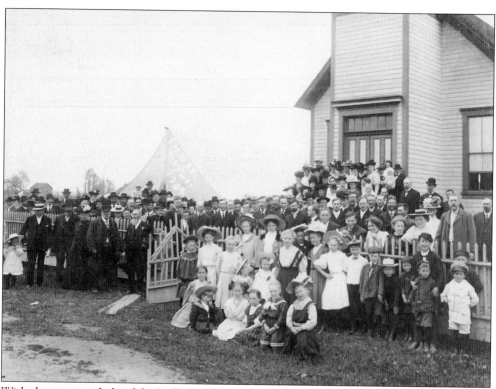

With the generous help of the Ladies' Aid Society, the Fir Lutheran Synode Church paid $40 to purchase a half-acre from Alex Johnson to build the first Fir church. The church, built in 1896, measured 24 feet wide by 42 feet long. This unidentified celebration took place on May 26, 1909, as stated on the banner in the background. (Solveig M. Lee.)

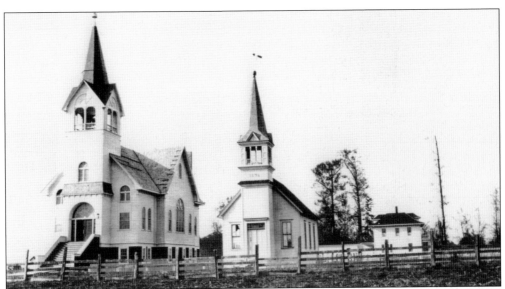

In the c. 1916 photograph above, which looks north from the Fir Island Road, the new (left) and old Fir churches stand side by side with Ole J. Borseth's newer home to the right. The 50th combined anniversary of the Fir and Conway churches is shown below and was held on October 9, 1938. After the original Lutheran congregation began in 1888 on the Ole N. Lee property on the east side of the south fork, a Lutheran church was built at Conway in 1895, and a Lutheran church was built at Fir in 1896. The new, larger church building was erected in 1914 and dedicated in 1916. The congregations of the Conway church and the Fir church merged in 1917. The Fir-Conway Lutheran Church (above, left) is still in service today. (Above, Dorothy Noste Johnson; below, Curt Tronsdal.)

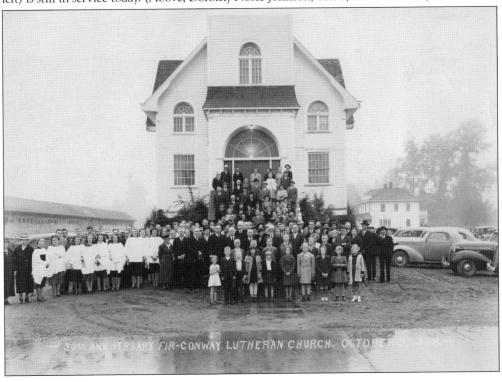

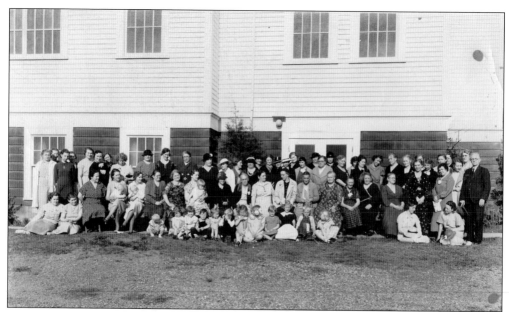

A large turnout of church women who were members of the Ladies' Aid Society gathered for this group photograph on the west side of the church in the 1940s. Being a member of the society was highly regarded, and the women assisted their church and community through charity work and fundraising. (Curt Tronsdal.)

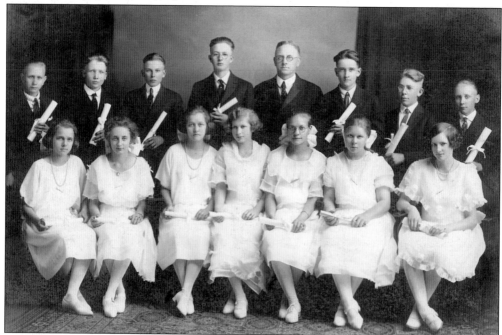

The members of this Fir-Conway Lutheran Church Confirmation class of 1923 are, from left to right, (first row) Louise Lange, Clara Hansen, Myrtle Lange, Lillian Quande, Valborg Brandt, Inga Tellesbo, and Louise Locken; (second row) unidentified, Ralph Robertson, Bjarne Sande, Halfdan "Hoff" Tronsdal, Rev. O.E. Heimdahl, Bjarne Siversen, Wilbur Siegel, and Alfred Sund. (Robert Sund.)

Confirmed in 1924 were, from left to right, (first row) Henry Mauseth and George Siegel; (second row) Louise Hall, Archie Omholt, Dagmar Heimdahl, Grace Lange, Lena Haugen, and Elmer Holm; (third row) Mildred Holm, Inga Haugen, Ragna Hanstad, Howard Boling, Alfred Alseth, Olaf Hytmo, and Gene Olson; (fourth row) Otto Hanseth, Rev. O.E. Heimdahl, Edgar Borseth, Alfred Moen (behind Edgar), Elmer Berg, and Nels Hegeberg. (Dorothy Noste Johnson.)

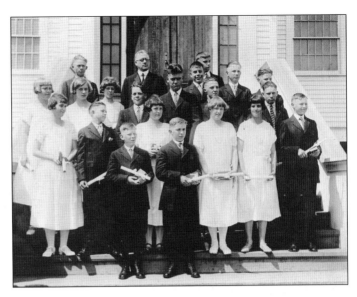

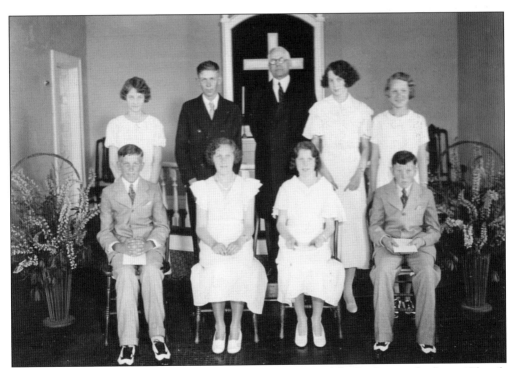

Shown in this c. 1930 photograph of the Confirmation class of the Fir-Conway Lutheran Church are, from left to right, (first row) Vernal Tingley, Alice Danielson, Lorraine Lee, and Millard Tingley; (second row) unidentified, Leslie Tennyson, Rev. O.E. Heimdahl, Lorraine Husby, and unidentified. (Diana Tingley Weppler; Millard and Marie Tingley collection.)

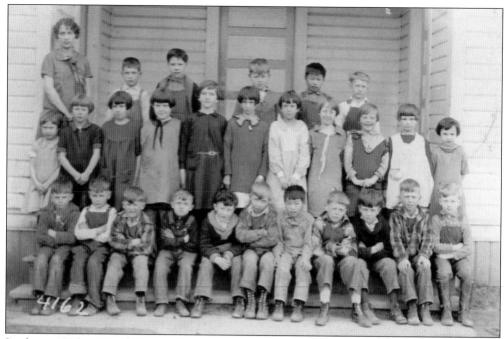

In the c. 1925 image above, teacher Palma Heimdahl stands with her students. From left to right are (first row) Charley Nelson, Vernal Lee, Donald Hallstrom, Richard Tucker, Verna Tingley, Leo Tellesbo, Mitugi Uysumi, Melvin Carlson, Millard Tingley, Harold Hallstrom, and Harnan Hanson; (second row) Virginia Tucker, Lenore Hallstrom, Grace Sparrs, Joan Sather, unidentified, Wilma Barsness, Bernice Anderson, Mildred Carlson, Helen Moen, and Margret Tucker; (third row) Ed Carlson, Willy Warner, Tore Sather, Kioshi Uysumi, and Irving Warner. Below, pictured around 1926 at Fir School, are, from left to right, (first row) Millard Tingley, Chris Omberg, Vernal "Red" Tingley, ? Hayton, Ferne Triber, Carol Sheldy, ? Iverson, and Merle Pettet; (second row) unidentified, Alice Danielson, Julie Omberg, Louise Erickson, unidentified teacher, Lois Heimdahl, Doris Longe, and Marion Hegeberg. (Both, Diana Tingley Weppler; Millard and Marie Tingley collection.)

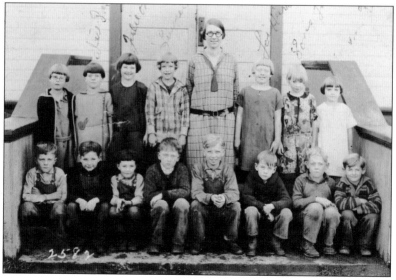

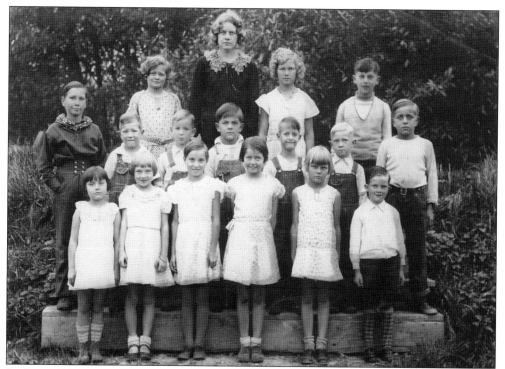

In this c. 1933 picture, students and teacher stand east of the Fir School by the dike on a slough. From left to right are (first row) Beverly Good, Molly Erickson, Joyce Franks, Dorothy Davis, Violet Bonde, and Elwood Bonde; (second row) Jim Hughes, Richard "Dick" Larson, Norman Hayton, Bill Davis, Don Erickson, and Richard "Dick" Hayton; (third row) Sy Good, Marion Hayton, teacher Myrtle Peterson, unidentified, and Franklin Good. (L. Richard Larson.)

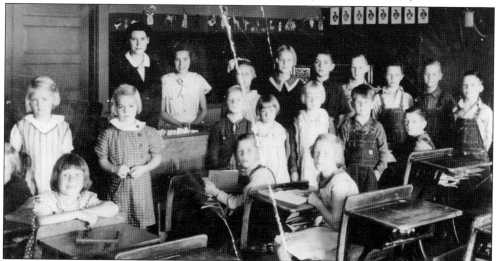

Teacher Irene Dickson, who later married Richard "Leroy" Hayton, is shown with her students in this c. 1937 photograph. The students pictured are, in no particular order, Joyce Franks, Beverly Good, Violet Bonde, unidentified, Richard "Dick" Larson, Elwood Bonde, Bill Davis, Jimmy Hughes, Connie ?, Barbara Hughes, Donald Davis, Pat Good, Jean Anderson, Donald Franks, Bob Larson, Mary Lou Good, and ? Mauseth. (L. Richard Larson.)

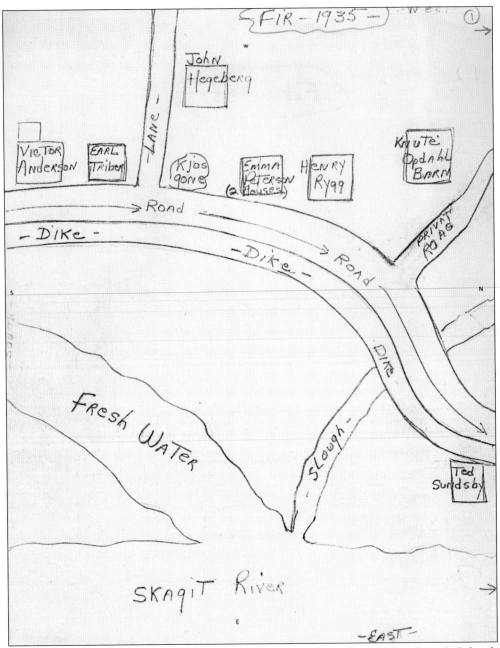

This 1935 sketch of Fir by Carrie Hanseth Brodland shows some changes from her 1915 sketch (see page 80). Victor Anderson is living next to Earl Triber, who is now living where Birger Johnson did. Ole Kjos's house is gone, but John Hegeberg still lives at his same place. Emma Peterson now owns both Peterson houses, and Henry Rygg is the only one living in the Olson-Rygg house. Knute Opdahl's barn is still in the same location. The bridge is gone over the Kickialli Slough, suggesting that a culvert has been placed under the road. The old dike is gone, replaced by a better dike following along the Mann Road. A private road now goes to Peter Hanseth's home, and Ted Sundsby now owns Howard Beck's house. (Vicki Carlson Archer; Rose Hanstad Carlson collection.)

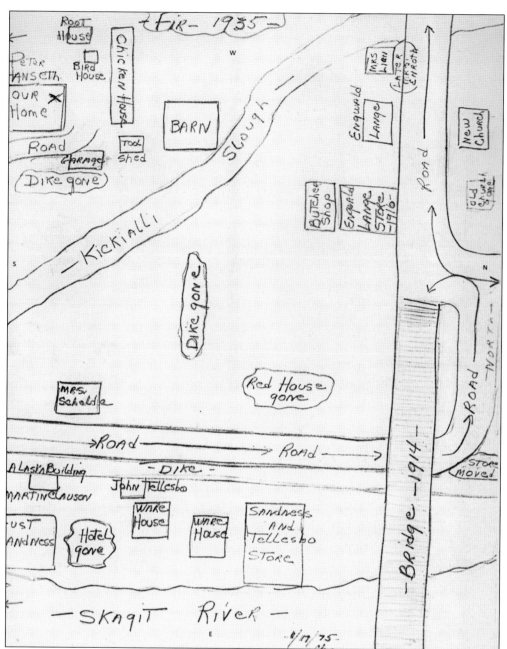

Since 1915, the inner dike has been removed, Mrs. Schelde lives in John Mauseth's house, Hirohito's red house is gone, and Borseth's store moved from north of the bridge to across from the church and is now the Longe-Triber Fir Merchantile Company. A butcher shop is located behind it. Other than a chicken house being built and the windmill being gone, Peter Hanseth's buildings remain the same. Envald Longe lives in the old Borseth house, and Mrs. Lien's house is to the west of it. The little old church is gone, and so is Borseth's windmill. Martin Clausen is now at the Alaska Building, John Tellesbo is now living in Ed Tellesbo's house, the hotel is gone, and another warehouse is nearby. Otherwise, the riverbank remained the same. (Vicki Carlson Archer; Rose Hanstad Carlson collection.)

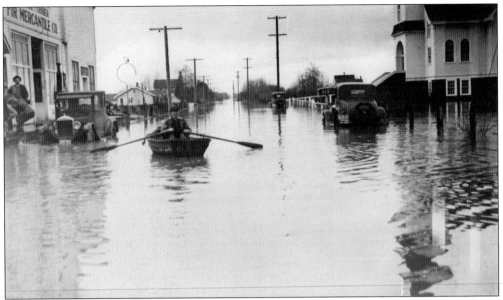

Flooding once again caused distress for residents on Fir Island in 1932. The Fir Mercantile Company, owned by Envald Longe and Earl Triber, is at left. A man rows a boat between the store and the church, and the automobiles have water halfway up the wheels. Looking west, the Fir Island Road is flooded as far as the eye can see. (L. Richard Larson.)

Many goods were sold at the Fir Mercantile Company, which was owned by Envald Longe and Earl Triber. John Krangnes carried this book with him when he came to buy goods at their store, which was located across the street from the Fir-Conway Lutheran Church. (Darlene Krangnes; Krangnes family collection.)

Oliver "Ollie" Wollan (far left) and his son Jack Wollan (far right) had finished a good day of fishing in the Skagit River before they stood by Ted Sundsby's fish shack for this photograph in the 1930s or 1940s. Sundsby weighed, bought, and sold fish. His fish business was located near the Mann's Landing site east of the dike and Kickialli slough. (Larry C. Wollan.)

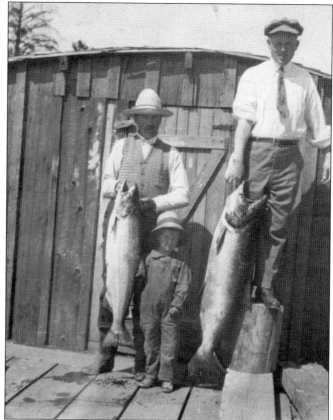

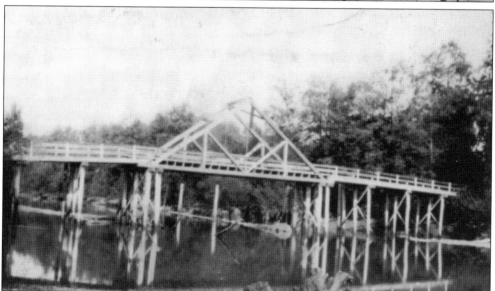

Lorenzen's Bridge, located one mile south of Mann's Landing, crossed Freshwater Slough to "the island." Carl and Anna Lorenzen came from Germany and had two children: Mary Ann and Lawrence. Their house was just northwest of the bridge. Although the bridge is gone, the house still stands today. (Arlyne Brodland Wollan and Larry C. Wollan.)

In this c. 1935 photograph, John Wylie (center background) is walking on a plank over a slough toward his barn. Wylie's son Jack and daughter-in-law *John's wife* Ellen Swanberg Wylie paused during their daily chores for a photograph with the family dog. Wylie purchased this farm around 1913. (Dallas R. Wylie.)

Ellen Swanberg Wylie stands beside the family car, a 1937 Chevrolet Coupe, in this c. 1938 photograph. Ellen, who was born in Sweden, was the *mother* ~~wife~~ of Jack Wylie and the daughter of Swan Swanberg. The family garden, filled with flowers and vegetables, is barely visible behind the car. (Dallas R. Wylie.)

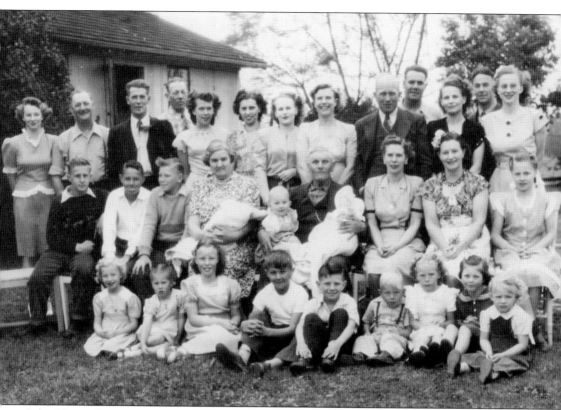

John Hanstad came to Fir in 1889. His father, Even Hanstad, arrived at Fir in 1887 to prepare a home for his family, buying property from G. Stackpole with gold coins. Annie K. Olson came to the United States in 1900, where she met and married Hanstad in 1901. The Hanstad family enjoyed having family reunions, and those pictured in this c. 1946 photograph are, from left to right, (first row) Glenda Carlson, Pattie Hanstad, Donna Carlson, Tom Valentine Jr., Eddie Hanstead, Richard Arp, Judy Arp, Rita Valentine, and Sandra Hanstead; (second row) Robert Hanstead, Jim Valentine, Bill Hanstead, Annie (holding Vicki Carlson), John (holding Linda Carlson and great-granddaughter Donna Lind), Mildred Hanstad Arp, Violet Hanstad Valentine, and Helen Valentine; (third row) Bonnie Carlson, Ted Carlson, John Arnold Hanstad, John Hallin, Dodie Hallin, Evelyn Hanstad Hallin, Lois Hanstead, Rose Hanstad Carlson, Frank Arp, Henry Hanstead, Faye Stearns Hanstead, Tommy Valentine, and Janet Nyberg Hanstad. The Hanstad (or Hanstead) name has been spelled several different ways. (Patricia Hanstad Pleas.)

Ellen Swanberg Wylie stands next to her father, Swan Swanberg, in this c. 1938 photograph. Her son Jack Wylie kneels in front of her with his young son Dallas Wylie, representing four generations. Jack was a dairy farmer and later became a Skagit County commissioner. (Dallas R. Wylie.)

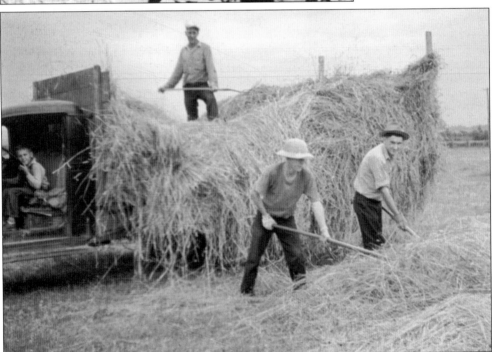

In 1946, at the age of nine, Dallas Wylie drove the hay truck while his father, Jack Wylie, stacked hay on the truck bed. Jim Wylie (left) and George Bowen used pitchforks to load the hay from the Wylie field. Bowen, a hired hand, was given a room in the Wylie home and ate all of his meals with the family. (Dallas R. Wylie.)

Fir Island and the Conway area have suffered many floods over the years. Two major floods occurred in February 1921. A break in a dike at Milltown on February 3 flooded the Pacific Highway, and another on February 21 caused flooding in Conway, Milltown, Stanwood, and the Skagit delta. The break pictured occurred during a flood in March 1932. (Maynard Axelson.)

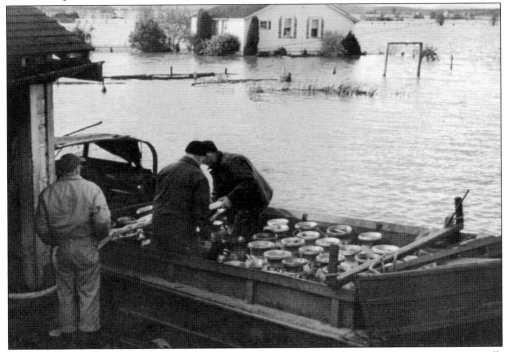

After Darigold bought out Carnation Milk Company, workers used a "duck" boat to transport milk from dairy farms on Fir Island during the October 1955 flood. Jim Wylie stands on the porch of the milk house while workers transfer milk cans. The force of high water from the Skagit River still threatens the residents of the area. (Dallas R. Wylie.)

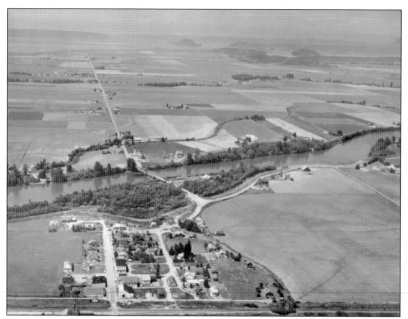

Crop land is everywhere in this view of Conway and Fir Island looking west across the Fir-Conway bridge and along the riverbanks on the east and west side of the Skagit River. This c. 1950s photograph was taken prior to the building of the I-5 freeway and the current bridge. (Curt Tronsdal.)

In this image of Conway and Fir Island looking south toward Milltown (at left), Skagit Bay is in the far background. The south fork of Skagit River (right) splits two ways. Freshwater Slough splits off to the right, and farther downstream, near Milltown, Tom Moore Slough splits off to the left. The south fork continues, and all waterways make their way to Skagit Bay. (Curt Tronsdal.)

Five

MILLTOWN

Settlers came to Milltown via boat, oxen, wagons, and later, trains. Logging provided a boost to the economy during the 1890s and early 1900s as up to 18 large and small sawmills were built in the area. Known mills at Milltown included the Hawley Mill, the Victoria Mill, and a lumber and shingle mill owned by Frederick Silvernail. Some historical records also mention a Williams Mill and a mill on the Lloyd place.

The Milltown School, established around the 1880s, was attended by local children prior to the road being built and going east from Tom Moore Slough. The schoolhouse sat at the top of the ridge just above the Lars Engen barn on the south side of Milltown Road.

The school had a play house, a teacher's cottage, and a gymnasium. This school remained open until it consolidated with the Conway School District in 1937–1938. Some of the school's buildings were still standing in the 1950s.

Milltown had a store, a boardinghouse, three saloons, a community hall/dance hall, and a pool hall. A post office was established there in 1901.

The communities around the area embraced the work of diking, land-clearing, road-building, farming, and working in the mills. Flooding, however, was a constant concern, much as it was with other towns near the Skagit River and sloughs.

On September 11, 1924, one of the shingle mills at Milltown caught fire and burned to the ground. At the start of the 20th century, lumber and shingle mills were plentiful in the area and were relied on by many families for employment. However, numerous fires between 1920 and 1940 negatively influenced this source of income, and Milltown residents were forced to seek work elsewhere.

In the mid-to-late 1930s, a fire started in the store at Milltown and spread to the boardinghouse, destroying both. The town of Milltown all but disappeared in the 1940s.

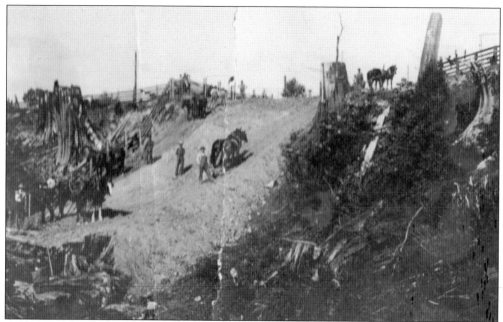

Logging and land clearing were no easy tasks for these settlers building a road east from Milltown around 1912. The hillside, located between the William Starbird and Lars Engen properties, had a severe incline, which became somewhat less steep after "slipscraping" dirt from the top to the bottom. (Warner A. Exelby.)

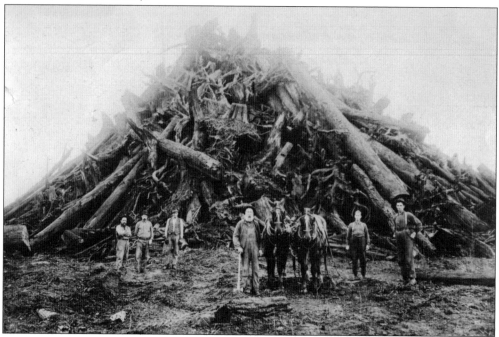

Logging was often followed by floods, embedding stumps, logs, trees, and other debris throughout the rich farmland. This "donkey pile," or stump pile, shows the result of hard work clearing land on the Lars Engen farm in 1918. Engen (center) stands next to the team of horses, and Edward Engen is at far right. (Curt Tronsdal.)

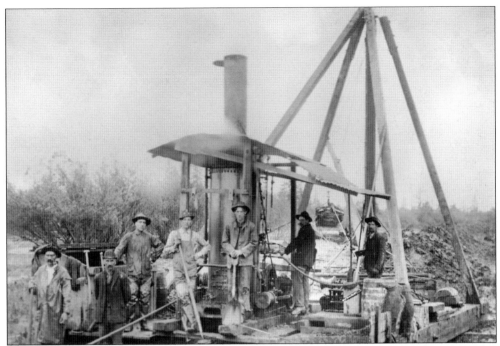

In the early 1900s, building dikes, clearing debris, and building bridges became urgent tasks due to flooding. Around 1915, these men worked on this steam "donkey." Pictured from left to right are two unidentified, Ole C. Noste, unidentified, John Borseth, Ole Thompson, and unidentified. (Howard "Bud" Tronsdal.)

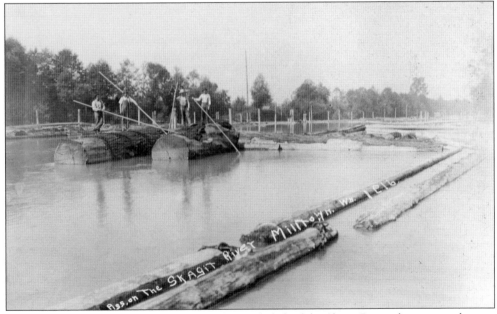

Looking north up Tom Moore Slough off the south fork of the Skagit River, these men—known as "slough pigs"—are busy at work getting logs to the Hawley Mill at Milltown. This photograph was taken southwest of the mill. The men on the logs are, from left to right, unidentified, William Swanson, unidentified, and Elmer Swanson. (Warner A. Exelby.)

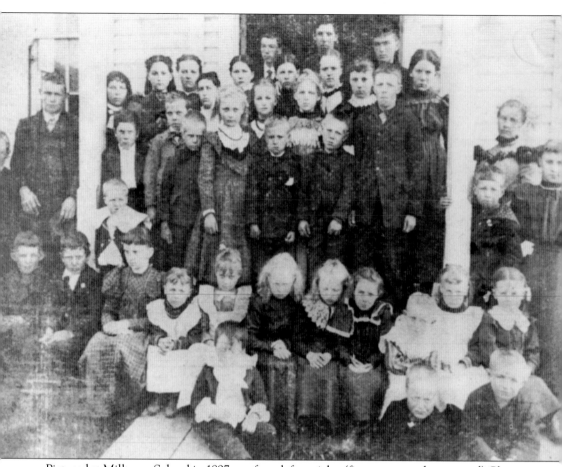

Pictured at Milltown School in 1897 are, from left to right, (first row, seated on ground) Clarence Gates, Ralph Larson, and Eddie Nelson; (second row, seated) Lorenzo "Wren" Silvernail, Clifford Skrondal, Victoria Arentzen, Beneita Gates, Annie Evenson, Thora Larson, Minnie Olson, Ida Nelson, Delfield Gates, Helda Nelson, and Lucy Danielson; (third row) Otto Nelson, Oscar Evenson, Nels Nelson, and Lester Silvernail; (fourth row) Louis Larson (partially obscured), Chester Lloyd, Eddie Skrondal, Donald Danielson, Einar Evenson, Emma Evenson, Bergliet Evenson, Gina Danielson, Oscar Nelson, teacher Edith Burrel, and Mary Arentzen; (fifth row) Maude Silvernail, Genevieve Marcus, Elida Evenson, Lula Silvernail, Mamie Johnson, Jennie Danielson, Alma Evenson, Christina Hemingson, and Dora Engen; (sixth row) Gustav Evenson, Ed Engen, and Leo Lloyd. Eddie Danielson is not pictured. (Curt Tronsdal.)

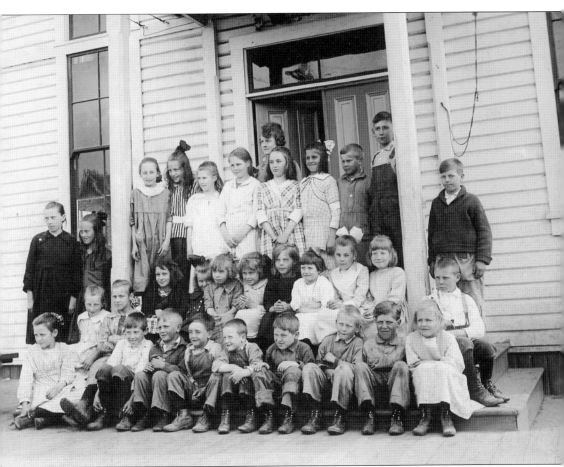

Students at the Milltown School gathered for a class photograph on May 11, 1920. From left to right are (first row) Florence Starbird, Helga Hanson, Cornelia Starbird, Einer Erickson, Charles Galbraith, Ed Darrow, Glenn Schwiekhardt, Charles Mann, ? Hanson, Floyd Faller, and Evelyn Evenson; (second row) unidentified, Edna Hastings, Elinor Conrad, Opal Schwiekhardt, M. Fleck, Eleanor Omholt, Dora Engen, Dorothy Martin, and Albert Swalling; (third row) Emma Erickson, Dorothy Astel, Clara Hanson, Francis Astel, Anna Erickson, Edna Fleck, teacher Miss Nellie Dock, Clarissa Darrow, Lina Haugan, Harvey Galbraith, Ralph Fryer, and Harold Omholt. The Milltown school, along with Fir, Cedardale, McMurray, and Meadow schools, consolidated with Conway School District in 1937–1938. (Curt Tronsdal.)

This charcoal drawing of Frederick Silvernail was made at the Seattle World's Fair in 1905, when Silvernail was 46 years old. Silvernail married Flora Adelaide George in 1880 at Gibbon, Nebraska. After traveling west in 1889, the couple settled at Milltown. He found work in a lumber mill and soon took over a homestead given up by a Swedish man who went back to his homeland. The land was covered with virgin timber, and Silvernail established a very successful sawmill there. Frederick and Flora had seven children: Roy, Maude, Lula, Lorenzo "Wren," Lester, Fred, and Arthur. The family operated the mill while Flora ran a boardinghouse for the millworkers. In 1907, Silvernail was killed after a fall from a horse-drawn lumber wagon. He was 47 years old and left behind a young wife and a large family. He was buried at Milltown cemetery not far from the family homestead. (Georgia Silvernail Fischer.)

Frederick Silvernail and his wife, Flora Adelaide George Silvernail, stand in front of their sawmill at Milltown with their family in this c. 1900 image. From left to right are Frederick, unidentified, Roy, Maude, Flora, Lula, Lorenzo "Wren," and Lester. The two young boys in front are Fred (holding the cat) and Arthur (beside the dog). (Georgia Silvernail Fischer.)

Flora Silvernail sits with her children in this July 1915 photograph. Pictured from left to right are (first row) Fred, Flora, and Arthur; (second row) Lester, Lula, Lorenzo "Wren," Maude, and Roy. Flora's husband, Frederick, died on September 22, 1907, and Arthur died at Stanwood on December 3, 1915—just five months after this portrait was taken. (Georgia Silvernail Fischer.)

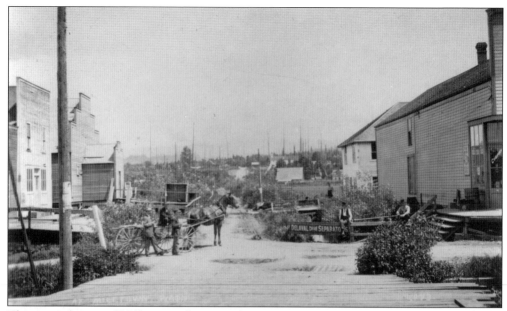

The original town of Milltown is shown in this c. 1910 photograph. A sign advertising Delaval Cream Separators acts as a barrier for the deep ditch beside the store. Looking east, the Milltown School house can be seen on the ridge above the Lars Engen farm. The saloon and dance hall/ community hall are on the left. (Stanwood Area Historical Society.)

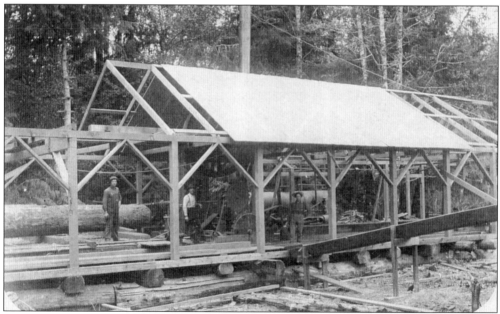

Harold Silvernail said that this lumber mill was located on the Skagit-Snohomish County line and that the owner also operated a shingle mill nearby. Chester and Selma Lloyd later lived near this location. Shown in the picture are, from left to right, Roy, Frederick, and Lorenzo "Wren" Silvernail. (Geogia Silvernail Fischer.)

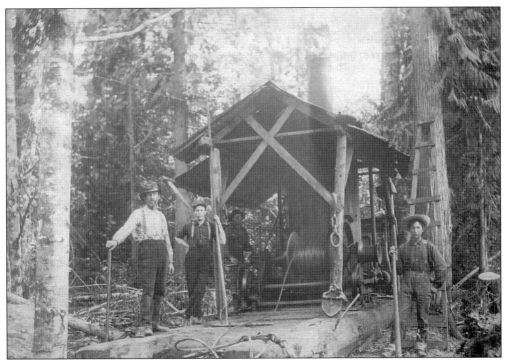

Frederick Silvernail (far left) and his son Lorenzo "Wren" (far right) work with a logging donkey set up in the woods near their home in this c. 1906 photograph. The other two men are unidentified. After using a cable and winch to get logs to the mill, they would mill lumber from the trees they had cleared from the land. (Georgia Silvernail Fischer.)

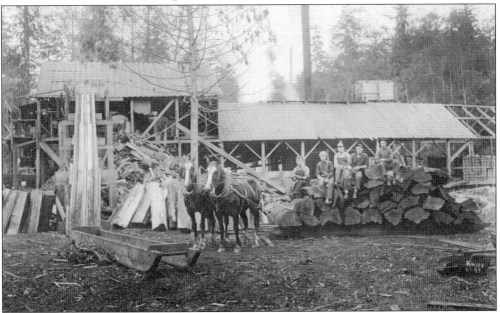

In this c. 1912 image, Lester Silvernail holds the reins of two horses (named Dolly and Jip) as he sits on a skid piled with shingle bolts at the mill owned by his father, Frederick. John Visten is next to Lester, followed by Arthur Silvernail; the others are unidentified. (Georgia Silvernail Fischer.)

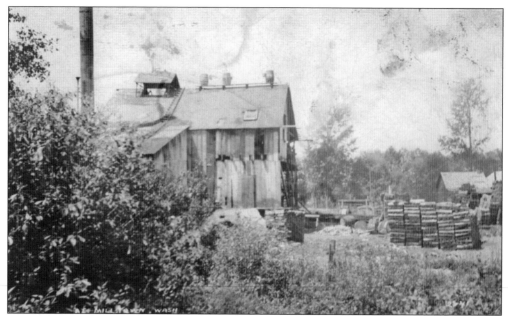

The Hawley Mill (sometimes referred to as the "Holly" Mill) was located north of Milltown on the east bank of Tom Moore Slough off the south fork of the Skagit River. This shingle mill employed many men and was located west of and below William Starbird's property. (Warner A. Exelby.)

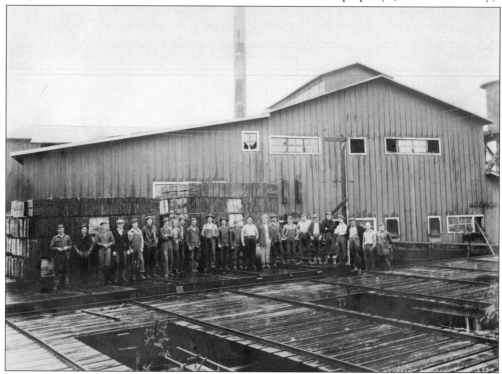

The Victoria Mill was a large lumber and shake mill and part of a thriving industry at Milltown. It was located south of Milltown and could be seen operating southwest of the Lars Engen property. This 1930s photograph shows 24 men employed by the mill. (Curt Tronsdal.)

Three young Silvernail brothers—from left to right, Arthur, Lester, and Fred—are taking a break from play to pose for a photograph. While living at Milltown in the early 1900s, they could often be found playing on the logs in millponds at their father's shingle mill or lumber mill. (Georgia Silvernail Fischer.)

Three of Frederick Silvernail's sons pictured in this c. 1915 photograph taken after Silvernail's death in 1907 are, from left to right, Lester, Fred, and Arthur. Arthur died in December 1915 at the age of 20. Silvernail's two older sons, Lorenzo "Wren" and Roy, are not pictured. (Georgia Silvernail Fischer.)

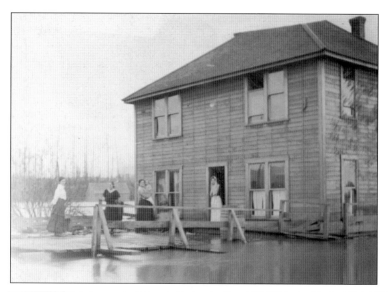

George Mann's house became the boardinghouse at Milltown. The house is surrounded by floodwater in 1909 as unidentified women perhaps contemplate what to do next. One woman holds a small child. The boardinghouse was located near the southeast corner of Pioneer Highway and Milltown Road. (Curt Tronsdal.)

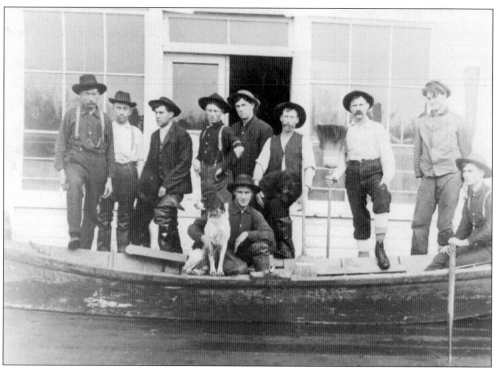

During the flood of 1909, these residents of Milltown found themselves surrounded by water and were forced to use a boat for transportation. The store, and also the saloon, were located at the intersection of Pioneer Highway and Milltown Road, about a quarter-mile south of the Hawley Mill. (Curt Tronsdal.)

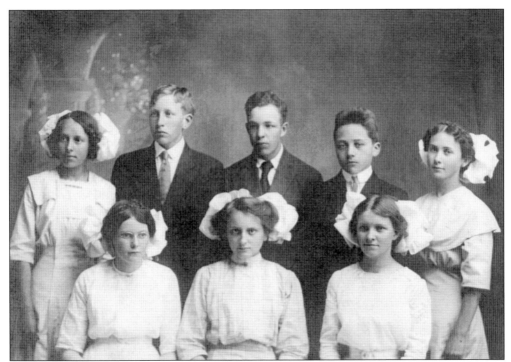

The Milltown school graduation class of 1912 consisted of three boys and five girls. From left to right are (first row) Emma Engen, Gina Paulson, and Ellevine Lian; (second row) Maria Astel, Chris Larson, Arthur Silvernail, Freddie Oars, and Lena Gates. (Georgia Silvernail Fischer.)

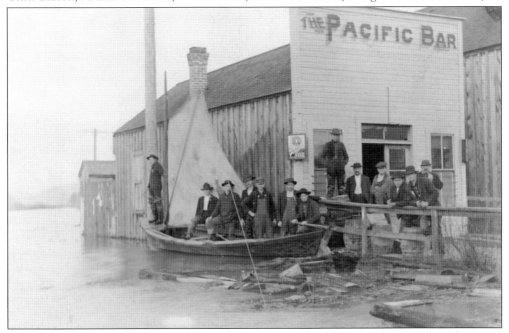

The Pacific Bar at Milltown is surrounded by floodwater in this 1909 photograph. A beer sign is visible on the corner of the bar. The men are readying to depart in this combination sail- and rowboat, and flood debris has washed up along the roadside. (Curt Tronsdal.)

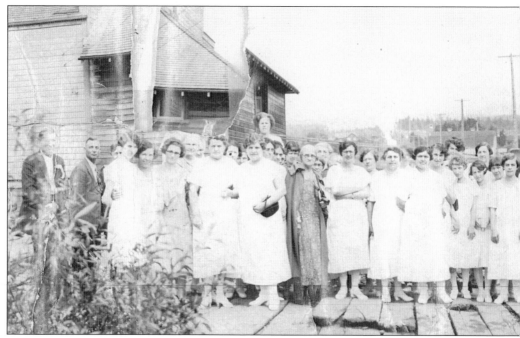

These two photographs are part of one large image taken during the State Convention of Royal Neighbors of America held at Milltown in 1916. At the time, women were not allowed to vote or to own property or life insurance, so nine women from Iowa founded the Royal Neighbors of America, which became one of the largest women-led insurers in the nation. Above, the saloon and community hall/dance hall is at far left, and Milltown Road is in the center background, Lars Engen's barn and house are to the right of the road, and George Mann's home (which became the boardinghouse) is at right. Below, the line of women continues from the boardinghouse (left),

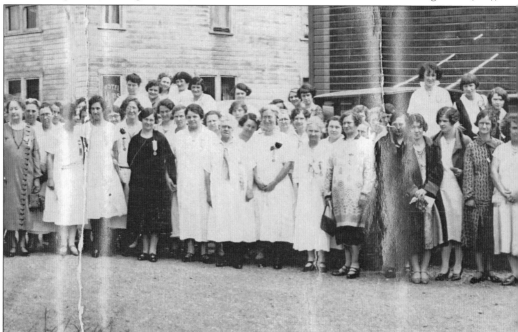

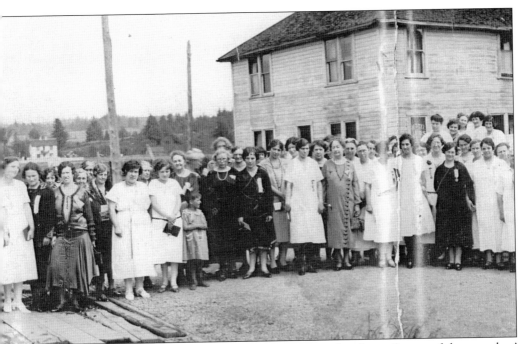

along the side of the Milltown Trading Company Store, and in front of many of the attendees' parked cars. Women were becoming empowered to better their lives through financial protection by owning life insurance and having opportunities to give back to their communities. In addition to providing life insurance for women, RNA stood firmly behind the women's suffrage movement. It also recognized that women lived longer than men and made sure that insurance premiums reflected that. RNA had a philanthropic mission of "neighbor helping neighbor." This convention was the biggest thing to ever happen at Milltown. (Both, Warner A. Exelby.)

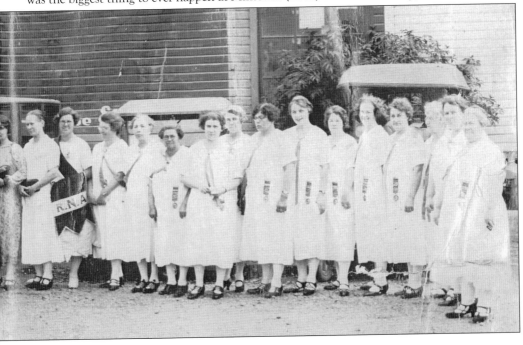

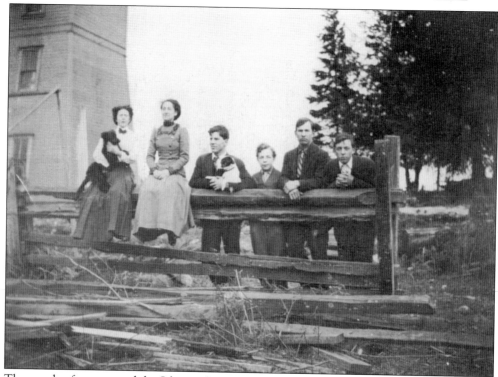

The wooden fence around the Silvernail property seemed a good location for this group to gather to have their photograph taken. They are, from left to right, unidentified, Lula Silvernail, Joe Dubuque, Arthur Silvernail, Lester Silvernail, and Fred Silvernail. Lula married Joe Dubuque on June 4, 1910. (Georgia Silvernail Fischer.)

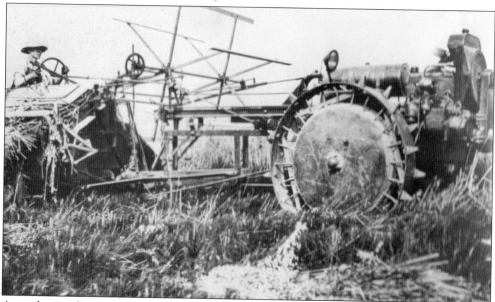

An early grain harvester, known as a "binder," was commonly used to cut grain, put it into a shock, and bind it together. The grain was then sent to a steam engine, where it was threshed. Threshing operations were located throughout the area during harvest time. (Howard "Bud" Tronsdal.)

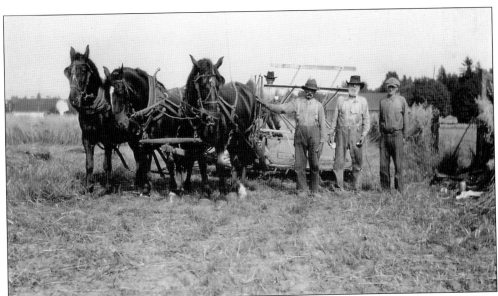

Harvesting oats on the Lars Engen farm in 1915 with a three-horse team and a binder are, from left to right, Edward Engen, unidentified, Lars Engen, and Gus Husby. The Engen barn is visible in the background at far left. This field was located south of Milltown Road. (Curt Tronsdal.)

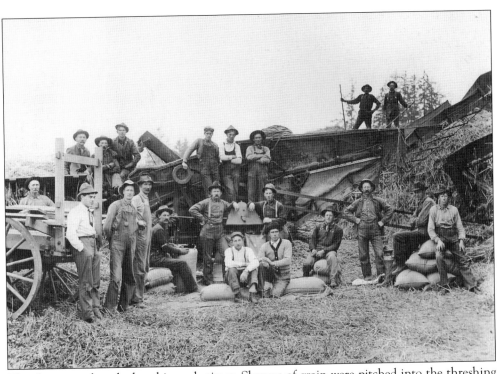

Threshing was done by hand in early times. Sheaves of grain were pitched into the threshing machine from a platform on the machine. Before automation, burlap was hand-sewn to make bags, filled with grain, and then sewn shut. These men are unidentified. (Curt Tronsdal.)

Amelia M. Swanson married William Simeon Starbird. The two of them owned the dairy farm on the north side of Milltown Road east to Franklin Road. Amelia worked for several years on the motor vessel *F.E. Lovejoy*. In this photograph, she stands on the deck of the *Gleaner* during a break from her duties as the cook. (Curt Tronsdal.)

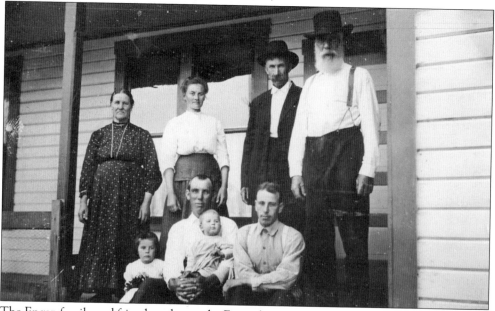

The Engen family and friends gather at the Engen home. Shown in this c. 1916 photograph are, from left to right, (first row) Helga Engen, Edward Engen (holding Agnes Engen), and unidentified; (second row) Elizabeth Engen, Olina Melkild Engen, ? Melkild, and Lars Engen. It is believed that young Dora Engen was at school. (Curt Tronsdal.)

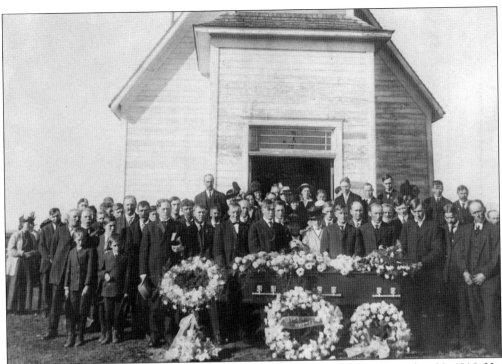

Hans Iversson Lund, a resident of Conway, died at Sedro-Woolley on September 20, 1916. His funeral was held on September 28, 1916, at the original Milltown church near the Scandinavian cemetery on County Line Road. Many mourners attended his funeral. (Curt Tronsdal.)

Lars and Elizabeth Engen immigrated to America in 1873. Their children, Dora and Edward, posed for this portrait in 1889. Edward was born in 1883, and Dora was born in 1886. Dora died in 1909. Edward married Olina Melkild in 1910, and they named their first daughter, Dora, after Edward's sister. (Curt Tronsdal.)

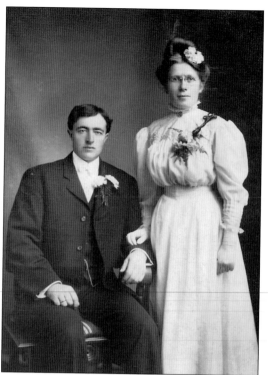

O.J. Edwards, a Lutheran pastor, performed the wedding of Sivert Tronsdal and Lena Wold in Snohomish County. They had three children: Halfdan "Hoff," Borghild S., and Owen "Tony." Sivert's brother John married Lena's sister, Hilde Wold. (Curt Tronsdal.)

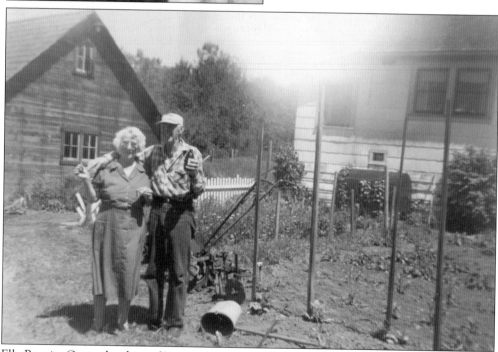

Ella Beneita Gates, daughter of Jasper Gates, married Elmer Johan Swanson in 1915; the couple is shown in this 1950s photograph at their home on the north side of Milltown Road. When William Starbird sold his property to the Engens, Elmer and Beneita bought two of the acres to build a home; their house still stands today. (Warner A. Exelby.)

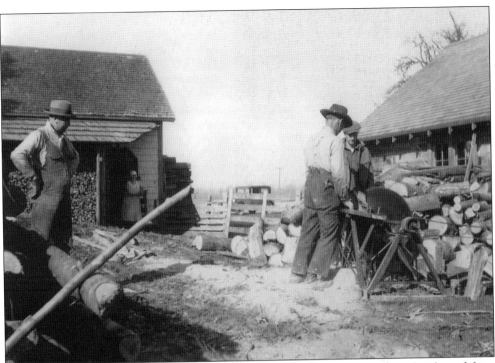

Wood was crucial for heat and cooking, and it was hard work to cut up a supply of wood for a year. Pictured in this late 1920s photograph are, from left to right, Ole Melkild, Olina Melkild Engen (standing near the entry to the shed), Edward Engen (at the buzz saw), and Gus Husby. (Curt Tronsdal.)

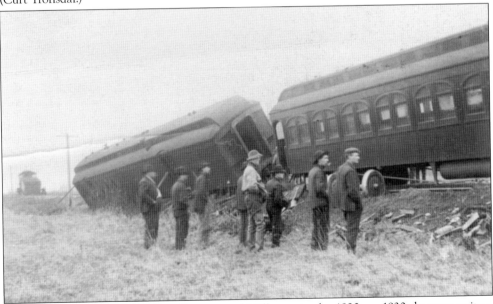

This train that wrecked between Conway and Milltown in the 1920s or 1930s became quite a curiosity for this gathering of onlookers. As a result of flooding, earth under the railroad tracks would often be undermined, which caused the loosening of railroad ties, spikes, and tracks. Those pictured here are unidentified. (Curt Tronsdal.)

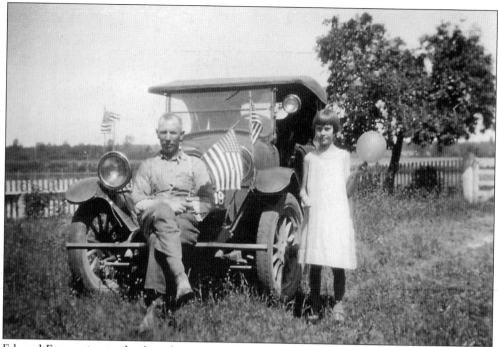

Edward Engen sits on the front bumper of his automobile on July 4, 1921, in this photograph looking north toward Conway. Young Helga Engen stands beside her father as they enjoy a day of celebration on the farm at Milltown. (Curt Tronsdal.)

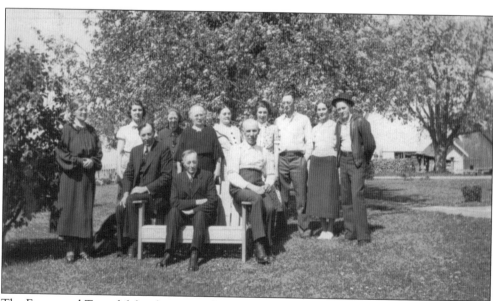

The Engen and Tronsdal families enjoyed this gathering in 1938. From left to right are (seated) John Tronsdal, Sivert Tronsdal, and Edward Engen; (standing) unidentified, Helga Engen, Borgehild Tronsdal, Lena Tronsdal, Elizabeth Engen, Dora Engen Tronsdal, Hoff Tronsdal, Agnes Engen Tronsdal, and Tony Tronsdal. Lena is the mother of Hoff and Tony. (Howard "Bud" Tronsdal.)

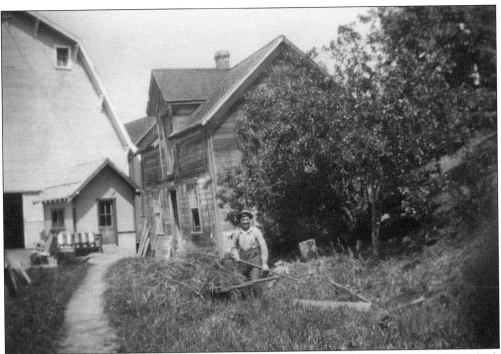

The Engen barn and milk parlor (at left) sit north of the older house where Lars and Elizabeth Engen raised their children. This house was located on the south side of Milltown Road, below the cemetery. Although the house is now gone, the barn still stands. (Curt Tronsdal.)

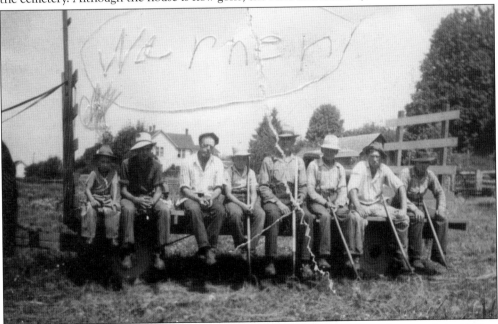

This haying crew sat on a hay wagon south of the Milltown Road for a photograph in 1939 or 1940. Pictured are, from left to right, Warner A. Exelby, three unidentified, Edward Engen, Gus Husby, and two unidentified; their pitchforks are at the ready for the next load of hay. (Warner A. Exelby.)

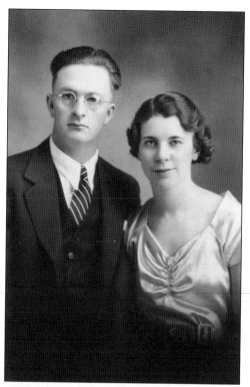

Hoff Trondsdal and Dora Engen were married on November 25, 1936, with Rev. O.E. Heimdahl performing the ceremony. Hoff, the son of Sivert Tronsdal and Lena Wold Tronsdal, was a farmer, and Dora, born at Milltown, was the daughter of Edward Engen and Olina Melkild Engen. (Howard "Bud" Tronsdal.)

Lars Engen homesteaded this land, and after his death, his son Edward took over the farm. Edward's daughter Dora married Hoff Tronsdal, and they later owned the farm, which was spread across about 200 acres. Dora and her husband had two children: Evelyn and Howard "Bud" Tronsdal. (Howard "Bud" Tronsdal.)

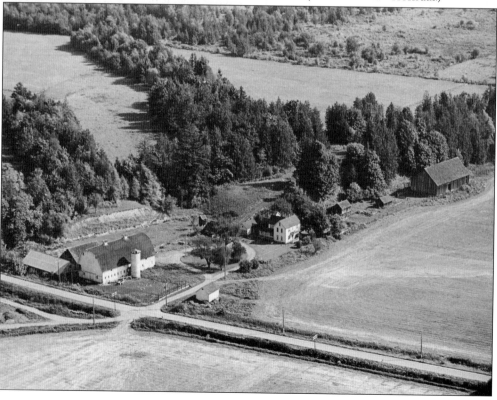

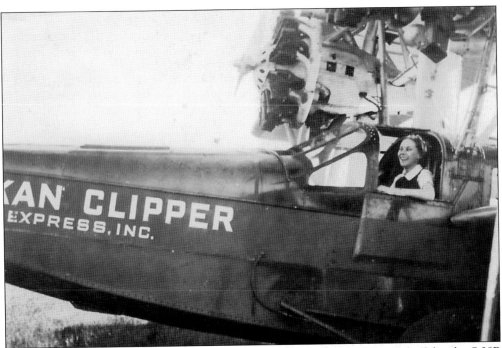

In this 1930s or 1940s photograph, Agnes Engen is sitting in the cockpit of a Sikorsky S-38B airplane operated by Alaskan Clipper Express in a field near the Engen farm. The plane was called a "flying boat" and had seating for eight to ten people. It had two 420-horsepower Pratt and Whitney Wasp engines, which are visible above Engen's head. (Curt Tronsdal.)

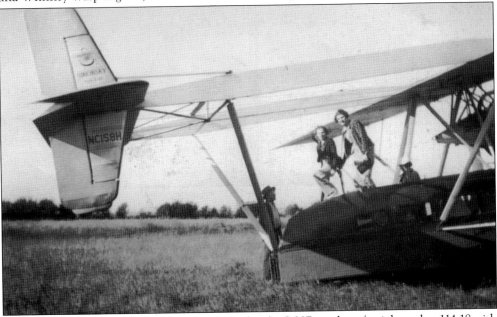

These two fans of aviation are exploring this Sikorsky S-38B airplane (serial number 114-18 with tail number NC158H). Agnes Engen (at right on top of the plane) is shown with three unidentified people after this plane landed near her home. Photographs of this plane are very rare. Engen married Tony Tronsdal. (Curt Tronsdal.)

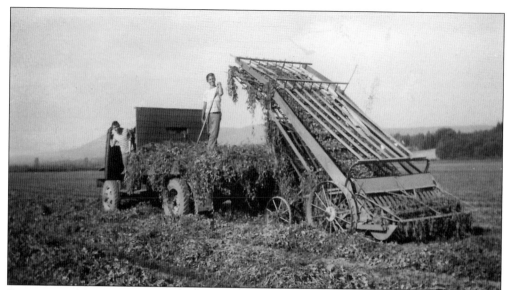

Peas were widely grown throughout the Skagit Valley after 1930. These two young farmers are loading pea vines onto a truck bed to haul them to the silo for storage. Young people of all ages worked in the pea fields either pitching vines or driving trucks; some of them were as young as nine or ten. (Curt Tronsdal.)

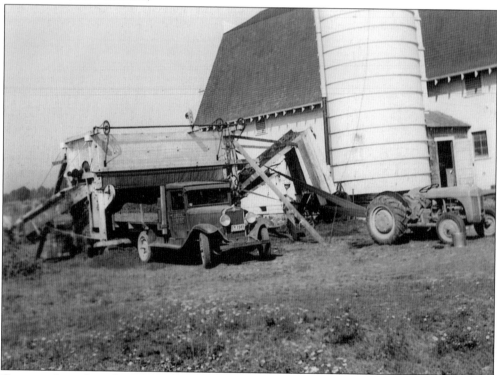

Green stock was brought in from the field, loaded into the silo, and allowed to ferment. To unload silage from a silo, a farmer would climb up the side, step onto the top layer of silage, and pitch the surface of the silage down a chute. This labor-intensive practice was alleviated by the invention of automatic unloaders in the late 1940s. (Curt Tronsdal.)

Processing plants sent out mobile pea-vining machinery in the late 1940s, which allowed peas to be vined in the field, then trucked to the processor. Hoff Tronsdal's 1946 Ford pickup is below the pea vine stack as workers pile the silage. South across Milltown Road are Tronsdal's barns and silo. (Warner A. Exelby.)

The people in this photograph are unidentified, but one young man is determined to walk with a pair of crutches on a narrow board plank above Tom Moore Slough to get in on the conversation. The mills ceased to operate by the 1940s, and the 1950s began a new era of transition. (Curt Tronsdal.)

BIBLIOGRAPHY

Barrett, Helen O'Brien, Anne Summers Carlson, and Margaret Willis, ed. *Skagit County Grows Up 1917–1941*. No. 7. Mount Vernon, WA: Skagit County Historical Society, 1983.

Bourasaw, Noel V., ed. *Skagit River Journal*. Sedro Woolley, WA: 2000.

Essex, Alice. *The Stanwood Story*. Vol. 1. *Stanwood News*, 1971.

Fir-Conway Lutheran Church. Seventy-fifth Anniversary Booklet. *Mount Vernon Argus*: 1963.

Royal, Dan, ed. *The Stump Ranch*. La Conner, WA: Skagit County Historical Museum, 2016.

Royal Neighbors of America. www.royalneighbors.org.

Sampson, Chief Martin J. *Indians of Skagit County*. Skagit County Historical Series No. 2. Mount Vernon, WA: Skagit County Historical Society, 1972.

Scandinavians of the Skagit Area: A Collection of Historic Essays from Skagit County Pioneer Families of Scandinavian Descent. Mount Vernon, WA: Snohomish Publishing Company, 2001.

Shiach, William Sidney, ed. *An Illustrated History of Skagit and Snohomish Counties*. Spokane, WA: Interstate Publishing Co., 1906.

Skagit County Washington Cemetery Records. Vol. 12. Conway, WA: Skagit Valley Genealogical Society, 2005.

Skagit County Washington Index to Funeral Home Records 1908–1994. Skagit Valley Genealogical Society, 1997.

Willis, Margaret, ed. *Chechacos All—the Pioneering of Skagit*. Skagit County Historical Series Vol. 3. La Conner, WA: Skagit County Historical Society, 1973.

Willis, Margaret, ed. *Skagit Settlers—Trials and Triumphs 1890–1920*. Skagit County Historical Series No. 4. La Conner, WA: Skagit County Historical Society, 1975.

Wood, L. Stedem. *Skagit Collection: Our Proud Heritage in Pictures*. Vol. 1. Mount Vernon, WA: Skagit Valley Herald and Skagit Valley Publishing Company, 2000.

INDEX

American Legion Hall, 48, 49, 57, 70

Borseth's Store, 8, 32, 63, 66, 71–73, 81, 91

Conway Auto Company, 29, 40, 51

Conway Fir Trading Union, 31, 35, 40, 42, 57

Conway Fire Department, 38, 52, 53, 57

Conway Hotel, 12, 31, 34, 35, 40

Conway Norwegian Evangelical Lutheran Church, 8, 34, 38, 40, 52, 85

Conway Meat Market, 29, 40, 48

Conway Motors and Machine, 41, 51, 56, 57

Conway Post Office, 31, 40, 41, 48, 57

Conway School, 13, 15, 28, 59–62, 99, 103

Dewey Utgard's Service Station, 43, 44, 55

Finstad and Utgard Creamery, 17, 30, 32, 33, 57

Fir-Conway bridge, 8, 17, 44, 49, 58, 63, 76, 79–81, 91, 98

Fir-Conway Lutheran Church, 2, 8, 38, 51, 52, 85–87, 92

Fir Lutheran Synode Church, 2, 24, 72, 77, 84, 85

Fir School, 15, 59, 75, 79, 88, 89, 103

First National Bank of Conway, 8, 17, 40, 42, 48, 57

Gleaner, 72, 116

Hawley Mill, 99, 101, 108, 110

John Melkild Store, 31, 41

Kikiallus tribe, 7, 9–11, 80

Longe–Triber Fir Mercantile, 63, 91, 92

Lorenzen's Bridge, 93

Mann's Landing, 7, 8, 32, 63, 66, 71–73, 75, 80, 81, 93

Mann's Landing Ferry, 8, 32, 63, 71, 76

Milltown Church, 117

Milltown School, 15, 59, 99, 102, 103, 106, 111

Noste Paint Store, 46, 48, 57

Royal Neighbors of America, 112, 113

Sandness Building, 67, 81, 82

Sandness and Tellesbo store, 63, 72, 73, 77, 81

Silvernail Mill, 99, 104–107, 109

Skagit City School, 13, 15, 16, 23, 59

Skagit Snag Boat, 26

Skrondal's Store, 41, 51, 57

Sons of Norway, 50, 53, 56, 57

Syttende Mai, 28, 36, 79

Sund Building, 24, 29, 40, 46, 48, 57

United States Indian Training School, 10, 12

Victoria Mill, 99, 108

Wollan's Duck Inn Tavern, 12, 47, 55

Discover Thousands of Local History Books Featuring Millions of Vintage Images

Arcadia Publishing, the leading local history publisher in the United States, is committed to making history accessible and meaningful through publishing books that celebrate and preserve the heritage of America's people and places.

Find more books like this at
www.arcadiapublishing.com

Search for your hometown history, your old stomping grounds, and even your favorite sports team.

Consistent with our mission to preserve history on a local level, this book was printed in South Carolina on American-made paper and manufactured entirely in the United States. Products carrying the accredited Forest Stewardship Council (FSC) label are printed on 100 percent FSC-certified paper.

MADE IN THE USA